POSTCARD HISTORY SERIES

New Orleans

POSTCARD HISTORY SERIES

New Orleans

Scott Faragher

ARCADIA
PUBLISHING

Published by Arcadia Publishing
Charleston, South Carolina

Printed in the United States of America

Library of Congress Catalog Card Number: 99-65055

For all general information contact Arcadia Publishing at:
Telephone 843-853-2070
Fax 843-853-0044
E-mail sales@arcadiapublishing.com
For customer service and orders:
Toll-Free 1-888-313-2665

Visit us on the Internet at www.arcadiapublishing.com

*For Katherine Harrington d'Iberville,
Princess of New Orleans.*

CONTENTS

ACKNOWLEDGMENTS

First and foremost, my sincere thanks go to Henry Juszkiewicz of Gibson Musical Instruments. Since the late 1800s, Gibson guitars, mandolins, and other stringed instruments have played a significant part in the development of American music. Nowhere has this been more evident than in New Orleans. I also extend my grateful appreciation and thanks to Sherrell Le Monie and everybody at the Olivier House on Toulouse Street; Ruthie Summit; Steve Brown at the New Orleans Country Club; and all the folks at Central Grocery and the Gumbo Shop. Finally, thanks go to Oswald Banks Lobrecue, Reigning Monarch of the Secret Krewe of Nimbus.

INTRODUCTION

Crescent City, The Big Easy, the Birthplace of Jazz, Sin City, America's Most Interesting City, America's Most Romantic City . . . these are just some of the names by which New Orleans is known. Whichever nickname is most appropriate, one thing is certain: New Orleans has a vibe unlike anywhere else in America. The energy is compelling, immediate, and unmistakable. Above all else, New Orleans is an international city, a melting pot of many races and cultures, each of which has added its own unique flavor and spice to the big stew. The French, Spanish, Italians, Irish, Africans, and Americans have all played their respective parts in creating this totally unique place.

From a historical standpoint, the city that would ultimately become New Orleans came to exist, after a fashion, on Mardi Gras Day (Fat Tuesday, Shrove Tuesday, the day before Ash Wednesday.) It was on this day, in 1699, that explorers stepped ashore after reaching the mouth of the Mississippi River and found a bayou that they named "Mardi Gras Bayou" in honor of the Catholic festival day. The area was subsequently settled, passed back and forth between the French and Spanish, and finally purchased from the French in 1803 as the result of James Monroe's Louisiana Purchase. Louisiana became a state in 1812.

New Orleans has survived and prospered, despite rule by foreign governments, the lost cause of the Confederacy, the horrors of Reconstruction, the ravages of yellow fever, and widespread fires and hurricanes. The major threat to the city today, and the one that poses the greatest danger to all American cities, is the willful destruction of significant architecture. Until 1900, or even later in some cases, if a wonderful house, an ornate theatre, or a grand hotel fell victim to the wrecking bar, it did not matter much, because something newer, but equally magnificent, was certain to replace the razed structure. Such is no longer the case. Cold steel and glass super-skyscrapers rise from the ground where architectural gems once stood. Worse still, prefabricated, box-like aluminum, cinder block, and plywood "buildings" have taken over what were,

at one time, prosperous urban neighborhoods. Convenience stores and gas stations have replaced the fine homes that once stood there. The supreme irony is that increased tourism in most areas usually gathers around a city's "Historic District," as is certainly the case in New Orleans.

Though New Orleans has already lost more important buildings than many larger cities ever had, it still retains its unique original flavor. The magnificent mansions of the Garden District, the great buildings in the central Business District, and the spectacular houses and shops of the French Quarter each possess a grandeur unparalleled anywhere else in America. The scenes presented in this book are taken primarily from old photographs and postcard images, and, as such, they represent a small but important part of New Orleans history. As I compiled these images, I was overcome by a deep sense of personal loss at the parts of New Orleans I had missed. The French Opera House, the St. Charles Theatre, the first two St. Charles Hotels, the Cave in the basement of the Grunewald Hotel, the St. Louis Hotel, the Three Oaks Plantation, and the Southern Railway terminal building were all gone before I was born. Other things, like a walk through the lobby of the St. Charles Hotel, which still existed until 1974, or a glass of Jax beer, I could have experienced, but didn't.

On the brighter side, much of the history of New Orleans remains. The St. Louis Cathedral, the Pontalba Apartments, indeed all of Jackson Square, look much the same as they did a century ago. Certainly, the majority of houses and great buildings, built within the Vieux Carre since 1800, are still standing, as are a great many of the mansions in the Garden District.

And yet New Orleans is so much more than its great architecture, location, climate, or even its long and colorful history. New Orleans is unique in America, and the world. Hopefully, the images presented in this book will provide a glimpse of New Orleans life and architecture as they have developed during the first half of the 20th century.

One

WELCOME TO THE
CRESCENT CITY

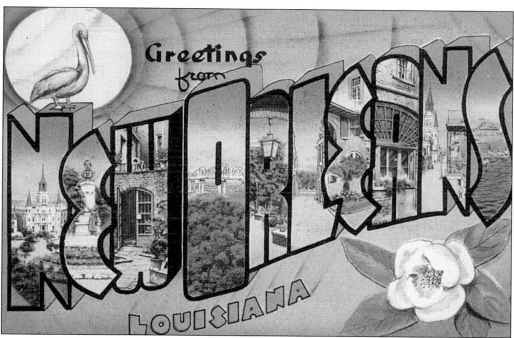

GREETINGS FROM NEW ORLEANS. This greetings card shows famous and familiar landmarks placed within the outlines of the letters comprising "New Orleans." Among them we see the St. Louis Cathedral, the Governor Claiborne House, and the Huey Long Bridge. These sights provide a representation of both new and old in the city. (Courtesy of Louisiana News Company, New Orleans.)

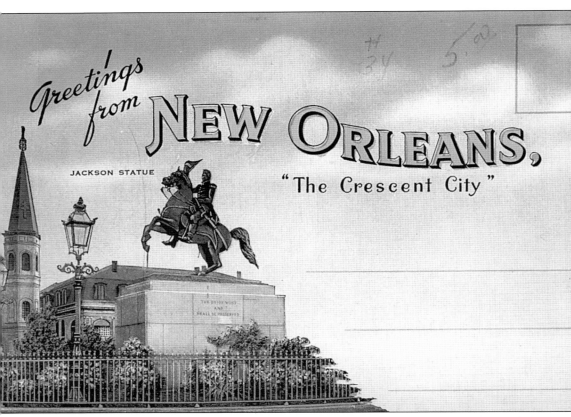

GREETINGS FROM THE CRESCENT CITY. This greetings card shows the St. Louis Cathedral, a traditional gas light, and the statue of Old Hickory in Jackson Square.

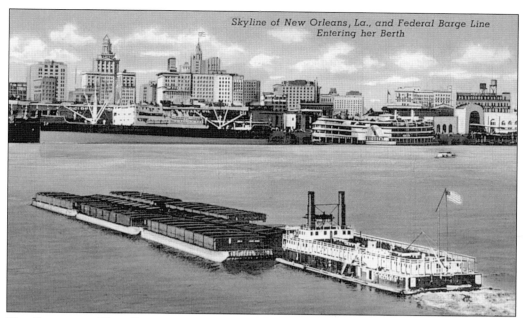

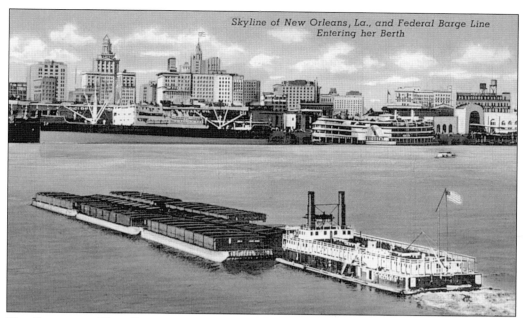

*Skyline of New Orleans, La., and Federal Barge Line
Entering her Berth*

THE SKYLINE OF NEW ORLEANS AND FEDERAL BARGE LINE ENTERING HER BERTH. Excluding the addition of a few taller and more recent buildings, New Orleans looks much the same today from this angle as it did when this image was made in the late 1930s. At that time, the city had a population of 500,000, an area of 200 square miles, and was America's second busiest seaport. (Courtesy of A. Hirschwitz, New Orleans.)

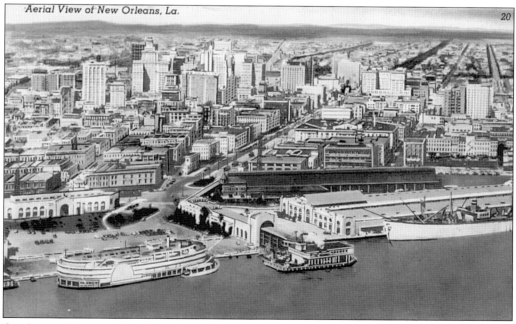

Aerial View of New Orleans, La.

AN AERIAL VIEW OF NEW ORLEANS. This view again shows the city from the Mississippi River. The aerial perspective provides an indication of its size and layout. Lake Pontchartrain is visible in the distance. (Courtesy of Louisiana News Company.)

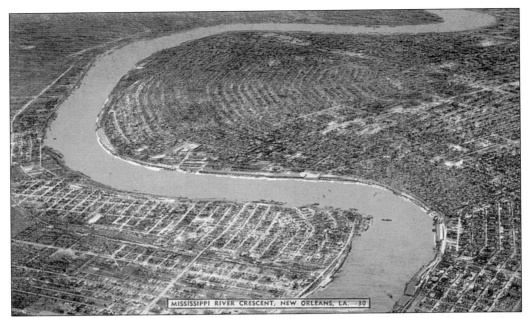

MISSISSIPPI RIVER CRESCENT, NEW ORLEANS, LA.—30

THE MISSISSIPPI RIVER CRESCENT. Like many other significant cities throughout America, New Orleans possesses more than one recognizable nickname. Among these names are "America's Most Interesting City" and "America's Most Romantic City." This view from the air clearly shows why the name "Crescent City" has become the most widely used.

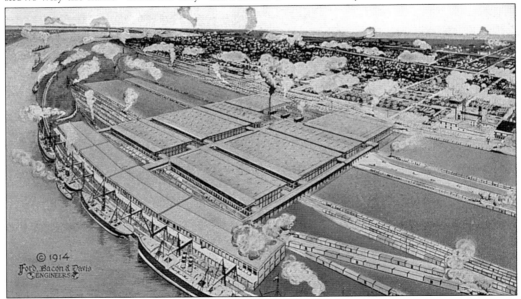

© 1914
Ford, Bacon & Davis
ENGINEERS

THE PORT OF NEW ORLEANS. By 1914, when this image was produced, New Orleans was a major seaport. Its location, at the juncture of the Mississippi River's mouth and the Atlantic Ocean, provides a geographic significance that no other coastal seaport can match. The buildings pictured are the Public Cotton Warehouses and Terminal, which were produced at a cost of $3.5 million. The organization handled 425,000 bales of cotton per day, making it the largest cotton facility in the world.

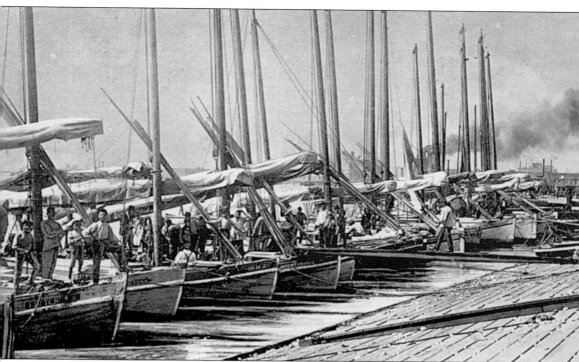

LUGGERS' (PICAYUNE) LANDING. In the days before automobiles, small boats were often used for business and pleasure. While rowboats were the primary means of transportation in the marshes and bayous, small sailboats like these were to be found on Lake Pontchartrain. Steam-powered, flat-bottomed riverboats plied the waters of the Mississippi River.

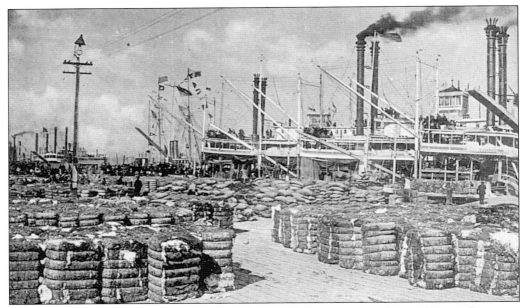

LEVEE SCENE ON CARNIVAL DAY. This photograph bears the inscription "Levee Scene on Carnival Day." The riverboats appear to be preparing to load the hundreds of large bales of cotton that are stacked on the dock.

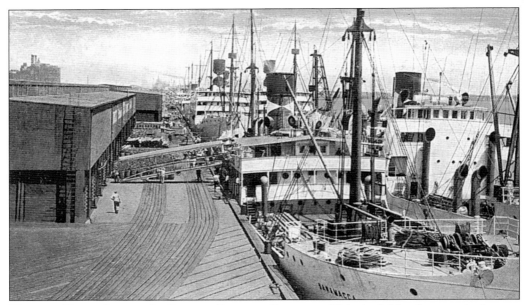

HARBOR VIEW, AMERICA'S SECOND LARGEST SEAPORT. This dockside photograph shows a New Orleans seaport, *c.* 1920s. Ocean-going vessels are berthed side by side, as is common at all busy seaports.

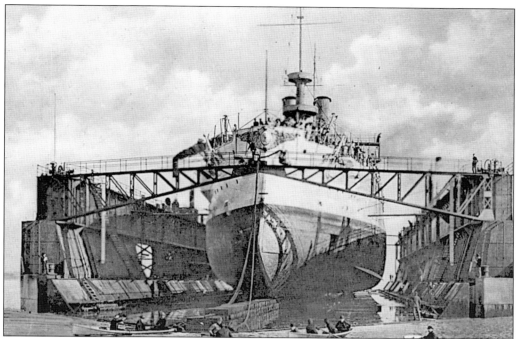

THE U.S. BATTLESHIP *ILLINOIS*. In addition to serving as a seaport, New Orleans, at one time, possessed the largest dry dock in the world. Here, the battleship *Illinois*, built in the 1890s, is seen literally out of the water, resting on her keel. In this position, it is possible to service the lower hull, normally under water, as well as any other part of the ship.

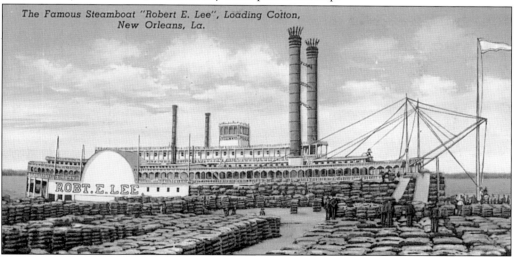

The Famous Steamboat "Robert E. Lee", Loading Cotton, New Orleans, La.

THE FAMOUS STEAMBOAT *ROBERT E. LEE* LOADING COTTON. The steamboat *Robert E. Lee* is one of the most famous riverboat side-wheelers of all time. Its defeat of the riverboat *Natchez* in a race on the Mississippi River forever insured this steamboat's place in American history. Despite what were palatial accommodations for the time, most passenger riverboats also carried cotton and other goods. Such was the case with the *Robert E. Lee*. The riverboats, then as now, were wide with low, flat hulls that enabled them to navigate the constantly shifting Mississippi River. (Courtesy of A. Hirschwitz, New Orleans.)

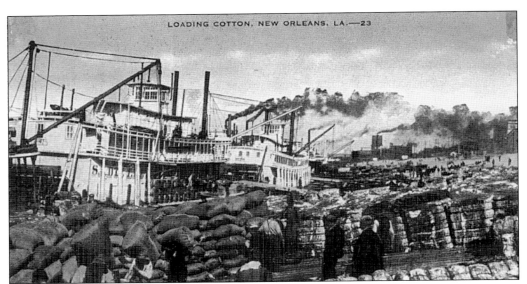

LOADING COTTON. The text on the reverse of this card states, "Husky, singing negroes handle these great bales of cotton as most people would handle bed pillows." This dockside scene is typical of the steamboat era. Cotton was brought to New Orleans on barges from the plantations upriver. The large bales were compressed, wrapped in burlap, and loaded for shipping to other destinations.

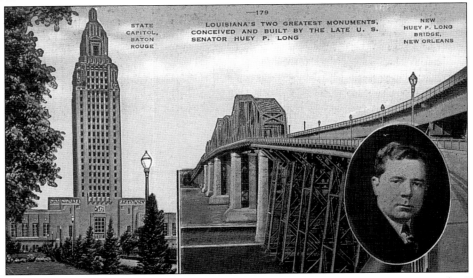

—179

STATE CAPITOL, BATON ROUGE

LOUISIANA'S TWO GREATEST MONUMENTS, CONCEIVED AND BUILT BY THE LATE U. S. SENATOR HUEY P. LONG

NEW HUEY P. LONG BRIDGE, NEW ORLEANS

LOUISIANA'S TWO GREATEST MONUMENTS. Louisiana's two greatest monuments are the Huey P. Long Bridge and the State Capitol building (upriver in Baton Rouge). Huey Long, known as "The Kingfish," was, without doubt, Louisiana's most famous and colorful politician. As public service commissioner, governor, and then U.S. senator, he considered the public treasury his own bank account, and established the strongest political machine ever seen in the Pelican State. He organized a "Share Our Wealth Society," and advocated the redistribution of wealth, which then, as now, meant redistributing somebody else's so-called wealth while maintaining your own. Despite these socialist leanings, Long accomplished a great deal in his time, prior to his assassination in 1935 at the age of 42. (Courtesy of New Orleans News Company.)

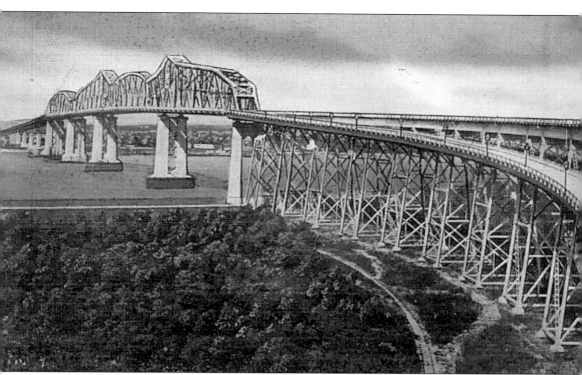

THE HUEY P. LONG BRIDGE. This $13 million bridge across the Mississippi River is 4.4 miles long, including approaches. It affords a vertical clearance of 135 feet, a 790-foot horizontal clearance, and at 409 feet high, is as tall as a 36-story building. In addition to the automobile lanes, the bridge provides railroad passage and was, at the time of its construction in 1936, the longest railroad bridge in the world. The bridge, with its foundation 170 feet below the river's surface, joins what used to be called the Old Spanish Trail, from east to west, and the Jefferson Highway, from the Gulf of Mexico to Canada. Long was killed shortly before the bridge was finished. (Courtesy of C.B. Mason, New Orleans.)

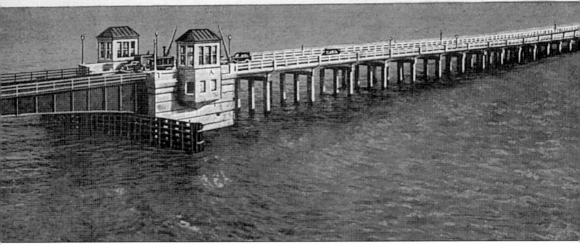

THE PONTCHARTRAIN BRIDGE. This 5–mile–long, $5.5 million bridge is built of concrete, and spans Lake Pontchartrain from the north shore of the lake at Slidell, LA, down to Pointe Aux Herbes, south of New Orleans. (Courtesy of New Orleans News Company.)

Two

THE FRENCH QUARTER

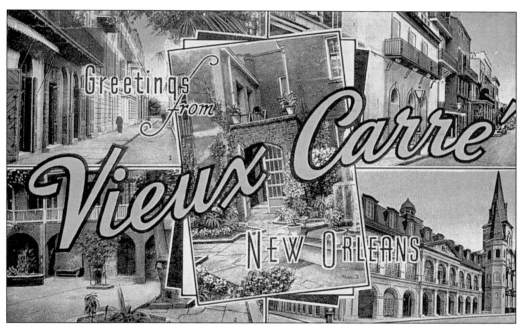

GREETINGS FROM VIEUX CARRE. The name "Vieux Carre," which translates into "Old Square," is synonymous with the fabled French Quarter. Among the scenes pictured here on this postcard are St. Anthony's Alley, several courtyards, the Cabildo, and St. Peter Street. "Greetings From" cards like this one have long existed, and were produced for most major cities by a variety of different, though usually local, publishers. (Courtesy of New Orleans News Company.)

The fabulous French Quarter itself has long served as a magnet for writers, adventurers, the interesting, and the interested. Within this 6-by-13-block area, bordered by the Mississippi River and Canal, Esplanade, and North Rampart Streets, exists the legendary historical area known as "Old New Orleans."

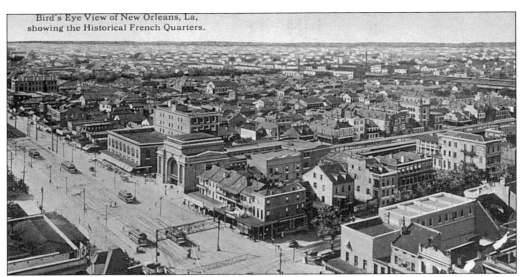

Bird's Eye View of New Orleans, La, showing the Historical French Quarters.

A Bird's Eye View Showing the Historical French Quarter. Automobiles are conspicuous by their absence in this early view of downtown Canal Street at Basin Street. The large building with the arched doorway to the left center of the picture was the Southern Railroad terminal. It was designed by Daniel Burnham, architect for Washington D.C.'s Union Station, and completed in 1908. It was one of several magnificent, now-demolished train stations that at one time graced the city.

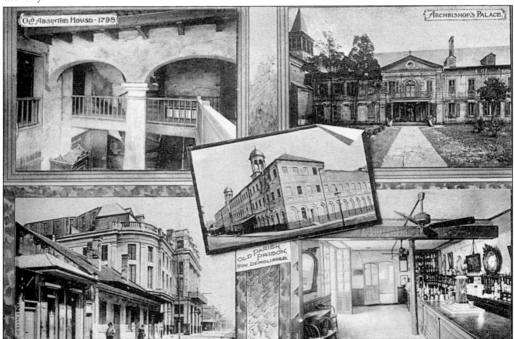

Old Landmarks of the French Quarter. This cluster of five photographs is undated, though it predates the burning of the French Opera House (lower left) in 1919. The Archbishopric's Palace and the Old Absinthe House are still standing. The Old Parrish Prison (center) is gone.

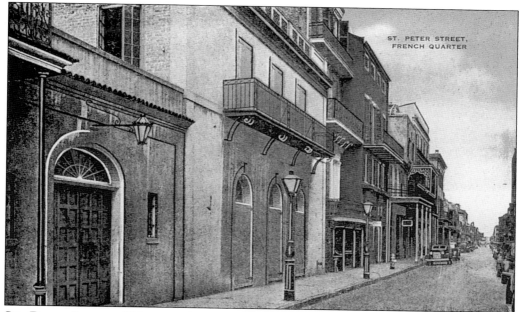

ST. PETER STREET. This street, located behind the St. Louis Cathedral, represents to many people the zenith of the Vieux Carre.

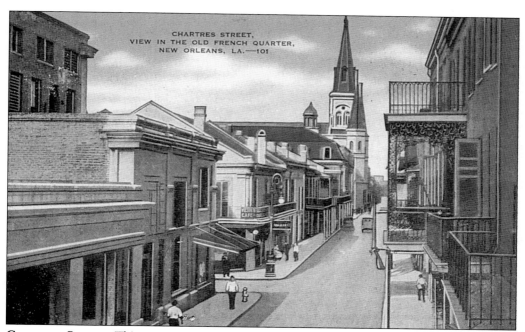

CHARTRES STREET. This street is the location of the St. Louis Cathedral, whose spires are pictured in the distance. Chartres Street runs, in a line, straight through the French Quarter, all the way from Canal Street to Esplanade Street. (Courtesy of New Orleans News Company.)

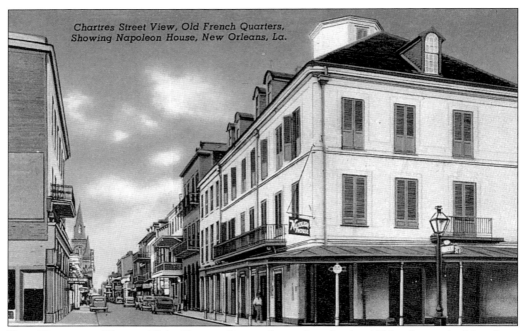

Chartres Street View, Old French Quarters, Showing Napoleon House, New Orleans, La.

THE NAPOLEON HOUSE. This Chartres Street view, taken in the 1930s, shows the Napoleon House on the right; in the distance on the left is the St. Louis Cathedral.

A PATHWAY OF PALMS. New Orleans is famous for its live oaks and palms, some of which are pictured here. This photograph was supposedly taken at the entrance to a residence in Algiers, part of New Orleans' 15th Ward. It appears, however, to be a picture of a priest at a church walkway.

ROYAL STREET FROM CANAL. Royal Street is pictured literally from the center of the road in this photograph, which was taken prior to 1900. It was on Royal Street that New Orleans furniture maker Prudent Mallard had his shop.

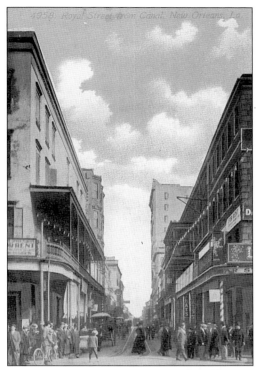

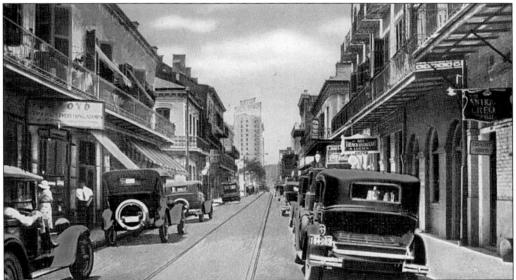

ROYAL STREET, VIEUX CARRE. Royal Street, which runs parallel to Chartres, is internationally considered to be one of the most significant antique centers in America. Here, in the epicenter of the French Quarter, one can find the most elaborate, and expensive, French and European paintings, art, furniture, and decorative items. This late-1920s photograph shows the Hotel Monteleone in the distant center. The trolley no longer runs on Royal Street, but the rails, now gone, are visible here. Unique and exquisite, Royal Street is unequaled today, as it was when this picture was taken.

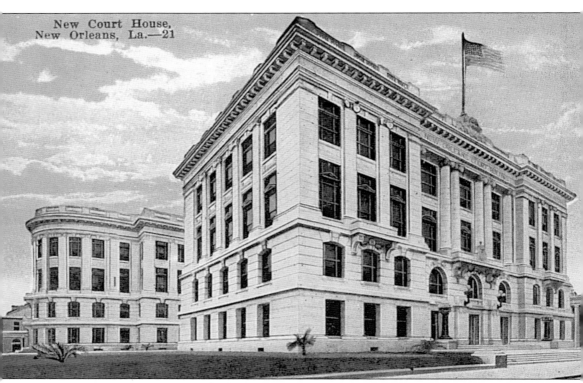

New Court House,
New Orleans, La.—21

THE NEW COURT HOUSE. The beautiful New Court House, at 400 Royal Street, was built in 1910 and used in that capacity for more than 45 years. For nearly the next 40 years, the building deteriorated slowly, a victim of heat, humidity, and neglect. Restoration was underway by the mid-1990s, and the building is again scheduled to serve as a court. Many people will recognize this structure from *J.F.K.*, the Oliver Stone movie.

THE HAUNTED HOUSE. This *c.* 1900 photograph shows some children and a couple of adults standing in front of the famous Haunted House. The building is located at 1140 Royal Street, which is at the intersection of Royal Street and the former Hospital Street, approximately 12 blocks from Canal Street. The house was occupied by Mme. Lalaurie, who treated her slaves with great cruelty, starving and torturing them to death. When her activities became known to the public, Mme. Lalaurie was forced to flee to France, where she subsequently died.

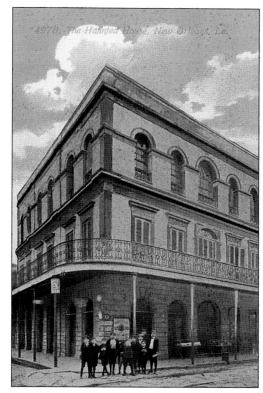

THE HAUNTED HOUSE, HOSPITAL AND ROYAL STREETS. This view of the Haunted House, probably taken around 1910, shows a wider view of the building. Note the rough stone street and the trolley car in the distance. The once-famous Haunted House is seldom mentioned these days. It was later called the Warrington House, and, for a while, it served as a home for destitute men and women.

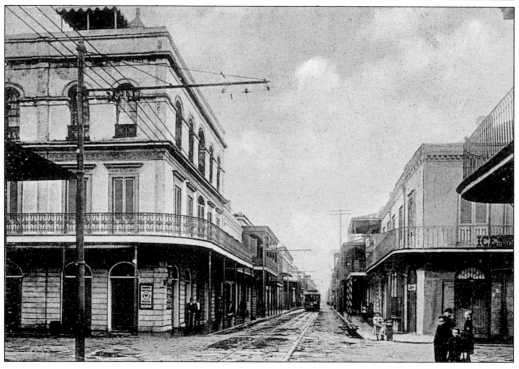

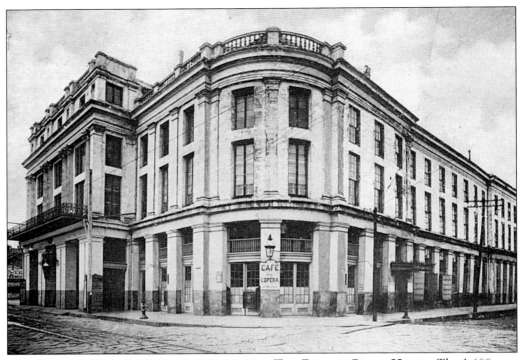

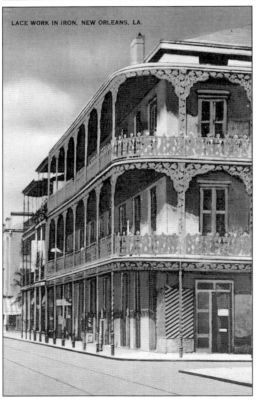

LACE WORK IN IRON, NEW ORLEANS, LA.

THE FRENCH OPERA HOUSE. The 1,600-seat French Opera House was located on the corner of Toulouse and Bourbon Streets, at the present site of the Inn On Bourbon Street. The Greek Revival-style auditorium, designed by Gallier and Esterbrook, opened in 1859, during the city's golden age, just prior to the Civil War. The auditorium was, for its time, a state-of-the-art theatre. There were many operatic theatres in New Orleans before 1900, including the unbelievably extravagant 4,000-capacity St. Charles Theatre. The St. Charles was the largest theatre in America when it was built in 1835. It burned in 1842, as did the French Opera House in 1919. While the St. Charles was New Orleans' grandest opera house, the French Opera House is most remembered. Its lasting memory is due, in part, to the significant number of remaining photographs.

LACEWORK IN IRON. This three-story building is typical of the many houses found throughout the French Quarter. Businesses often occupy the ground floors of what were once single-family homes, while the upper floors are rented as apartments.

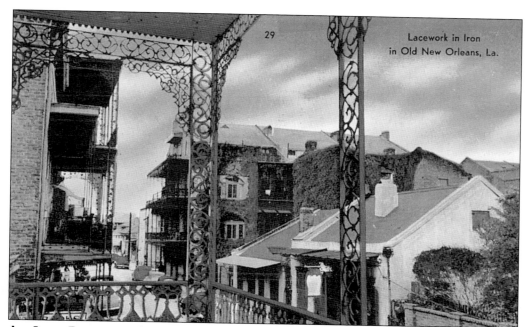

Lacework in Iron
in Old New Orleans, La.

AN IRON BALCONY. Though New Orleans is especially famous for its lacework balconies, fences, and courtyard gates, most of the cast and wrought iron actually came from New York, Philadelphia, and other places up north, prior to the Civil War.

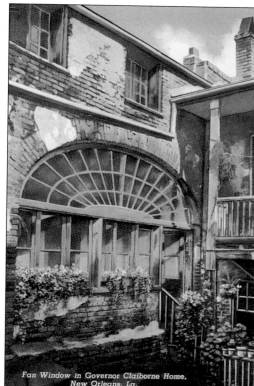

A FAN WINDOW IN GOVERNOR CLAIBORNE HOUSE. This elliptical fan window, at the house that was once occupied by Governor Claiborne, was at one time one of the most photographed scenes in New Orleans. Claiborne became the first American governor of the territory of Orleans, which, in 1812, became the state of Louisiana.

Fan Window in Governor Claiborne Home,
New Orleans, La.

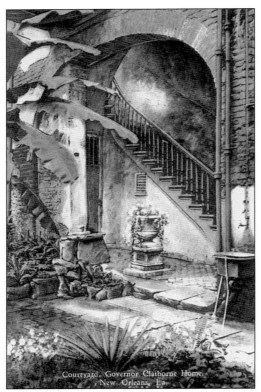

Courtyard, Governor Claiborne Home, New Orleans, La.

THE COURTYARD AT THE GOVERNOR CLAIBORNE HOUSE. The Governor Claiborne House remains one of the favorite houses in the historical French Quarter. This particular courtyard exemplifies the best mixture of classicism and decay. Note how the plaster has fallen off the bricks in this and the previous image. Plaster was affixed to the brick surfaces, both for appearance and to protect the brick and the Cypress beams. In the Vieux Carre, these open private courtyards provided walled gardens of refuge within the city. The scene here shows a large banana plant, some cut flagstone, and drainage pipes, all of which were aspects of a typical courtyard.

THE BRULATOUR COURTYARD. This scene of Brulatour Courtyard is interesting for several reasons. Firstly, both the house and its courtyard are fairly large. There are several potted plants situated on the cut-stone floor, and the circular planter in the foreground may have held a fountain at one time. To the left of the picture, through an alcove, there is a stairway leading to a second story (most likely where slaves, and then servants, were quartered). These smaller, separate residences usually adjoined the main house at the rear, or across the courtyard. The Brulatour Courtyard, located at 520 Royal Street, is one of the most photographed and painted courtyard scenes in the Vieux Carre. The house, now known as Brulatour, was built in 1816 by Francois Seignouret, a French wine importer. It became known as Brulatour during its occupation by Pierre Brulatour in the late 1800s. (Courtesy of New Orleans News Company.)

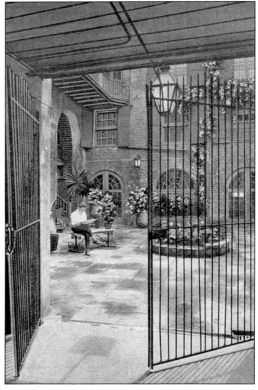

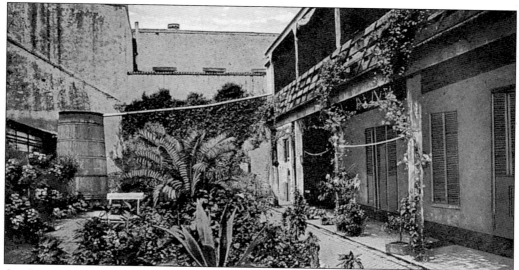

AN OLD SPANISH COURTYARD. This courtyard scene shows servants' quarters and, most probably, a kitchen extending away from the rear of the house. The kitchens, being the area of the house most likely to catch fire, were housed outside the main residence for safety reasons. To the left of the image is a large steel-banded wooden cistern, fed from a spout connected to the building's gutter. In this manner, water was collected during the frequent heavy rains.

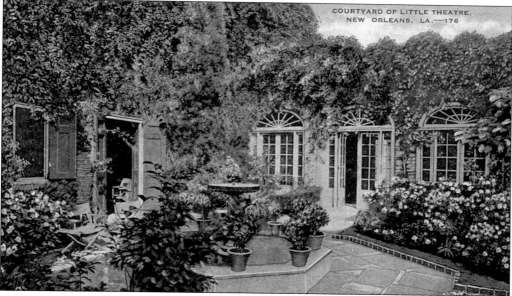

THE COURTYARD OF THE LITTLE THEATRE. "Le Petit Theatre du Vieux Carre," or Little Theatre, began in 1916 as the Drawing Room Players, and is one of the most recognized courtyards in the city. The house originally occupied by the theatre group was constructed in 1794, and it burned down the same year. It was rebuilt in 1797 for Don Manuel Gayoso de Limos, the last Spanish governor of Louisiana. This courtyard at 616 St. Peter Street, though considerably smaller than the Brulatour's, is well landscaped nonetheless. The vines and natural foliage, as seen here, had been allowed to completely cover the roof of the building. Today, the building's exposed brick has been painted and the vines removed. (Courtesy of New Orleans News Company.)

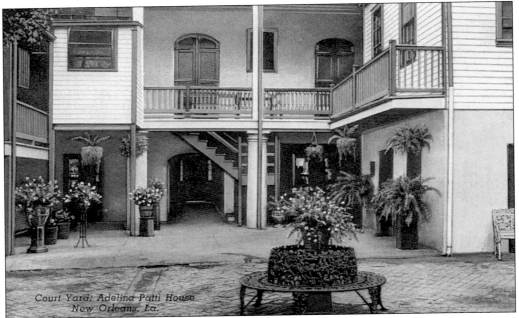

Court Yard, Adelina Patti House
New Orleans, La.

THE COURTYARD AT ADELINA PATTI'S HOUSE. This view shows the back of the house at 627 Royal Street, where the famous opera singer Adelina Patti lived for a year prior to the Civil War.

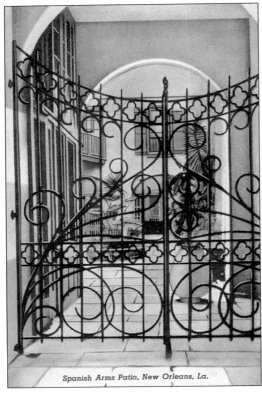

Spanish Arms Patio, New Orleans, La.

THE SPANISH ARMS PATIO. Though this building at 616 Royal Street, known as the Spanish Arms Court, was built in 1831, its heavy, but delicate, wrought-iron gates were taken, a century later, from the razed Masonic Temple.

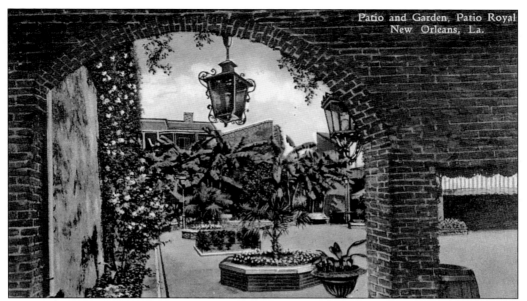

Patio and Garden, Patio Royal
New Orleans, La.

PATIO AND GARDEN, PATIO ROYAL. During the past two centuries, a house or property is likely to have changed hands many times. This structure, located at 417 Royal Street, was built in 1801 by Don Jose Faurie, a Spanish merchant, who sold it to the Louisiana Bank in 1805. It was purchased by Martin Gordon in 1820 before being acquired by Judge Alonzo Morphy. It eventually became the property of Tulane University, following the suicide of Ratcliffe Irby, its last private owner. Throughout its history, the house's various owners seem to have been plagued with misfortune; however, Owen Brennan, owner of the Old Absinthe House, committed himself to using the house as a restaurant. Today, half a century later, Brennan's is regarded as one of New Orleans' most famous restaurants.

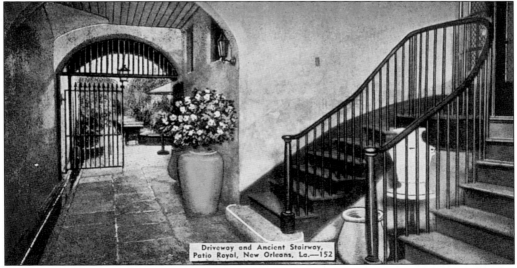

Driveway and Ancient Stairway,
Patio Royal, New Orleans, La.—152

DRIVEWAY AND ANCIENT STAIRWAY, PATIO ROYAL. Today, the stairway at 417 Royal Street is a part of Brennan's, one of the city's favorite restaurants. Other than the addition of a chandelier and the presence of a few benches, there has been little change in this scene since 1840.

31

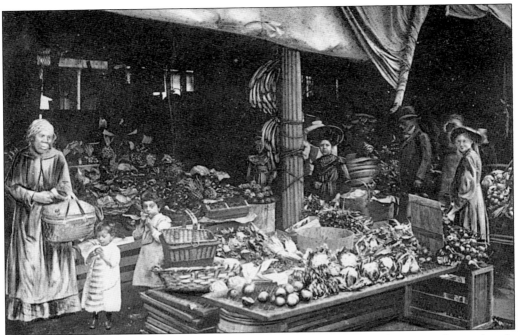

THE FRENCH MARKET, 1890S. This market, on Decatur Street, was but one of several early outdoor markets in the city. Supposedly built by the Spanish in 1791, virtually along the banks of the Mississippi River, the market was destroyed by a hurricane in 1812 but was rebuilt the following year. The photograph shows well-dressed patrons (to the right side of the image) casually shopping.

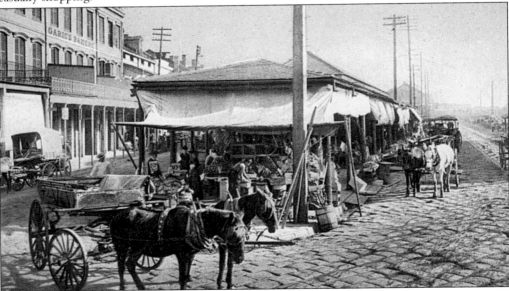

THE FRENCH MARKET, C. 1900. This scene shows the market looking somewhat primitive, with streets paved with cut stones and no automobiles in sight. This area of New Orleans was known as the "Italian District," owing to the fact that most of the stalls were operated by Italians. Such is not the case today.

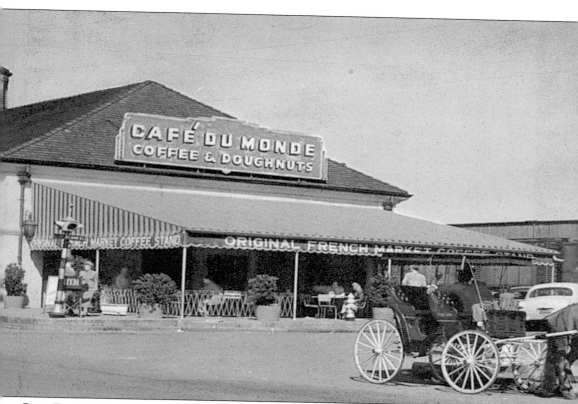

CAFE DU MONDE. Cafe Du Monde, located in the French Market, is arguably the most famous coffee stand in America. The menu is somewhat limited, but what more could anyone possibly want besides cafe au lait and beignets covered with powdered sugar? Today, Cafe Du Monde resembles this early-1950s photo, except that the awning has been replaced by a more permanent roof and extends much further. (Courtesy of Grant L. Robertson, Metarie.)

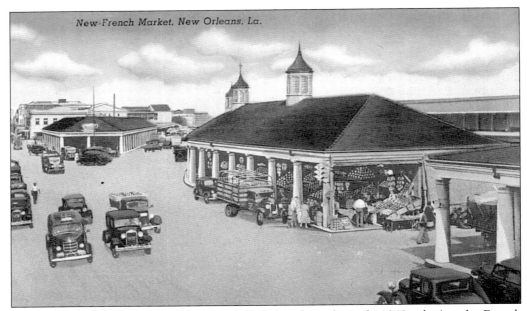

New French Market, New Orleans, La.

THE NEW FRENCH MARKET. This postcard, dating from the early 1940s, depicts the French Market in its present state, mostly as it has existed since being modernized in the late 1930s. Now, as in the past, the French Market is the place to buy fresh vegetables, seafood, jewelry, souvenirs, alligator items, and is a wonderful place for "people-watching." This view shows three of the market buildings, with Decatur Street to the left. (Courtesy of New Orleans News Company.)

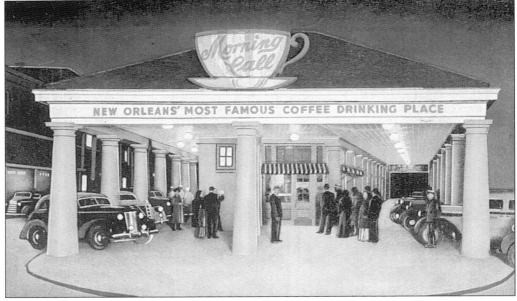

THE MORNING CALL. Sadly, the Morning Call coffee stand, as pictured in this early-1940s photograph, is no longer in business at the French Market. The stand had been in operation since 1870, and was patronized by the famous as well as the infamous. It was a favorite haunt of writer Tennessee Williams. Nowadays, the stand is located in Metarie.

THE U.S. MINT ESPLANADE. The U.S. Mint was built in 1835 on the site of the former 1790s San Carlos Spanish fort. The massive Greek Revival building was designed by William Strickland, who also designed the Tennessee State Capitol Building in Nashville. The building, which has an interesting history, served as a mint, producing coins between 1838 and 1909. General Beauregard, a West Point trained engineer, restored the mint's sinking foundations, and during reconstruction, a confederate patriot was hanged here for taking down the Union flag. Today, the imposing structure is owned by the Louisiana State Museum and houses the New Orleans Jazz Museum and the Mardi Gras Exhibit.

SAINT ANTHONY'S ALLEY. If you were to stand in Jackson Square facing St. Louis Cathedral, St. Anthony's Alley is on the right side of the cathedral. It extends between the cathedral and the Presbytere, all the way to Royal Street. It was once a promenade for the priests of the St. Louis Cathedral.

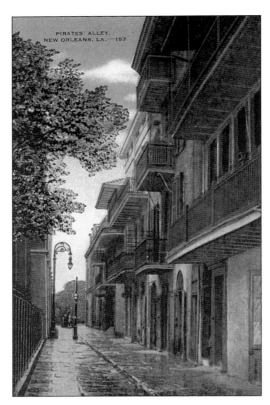

PIRATE'S ALLEY. Located on the other side of the cathedral, and parallel to St. Anthony's Alley, is Pirate's Alley. It was the route by which pirates were transported to the jail at the Old Spanish Cabildo, hence the name. It was at a house facing Pirate's Alley that William Faulkner wrote his first novel, *Soldier's Pay*, in 1925. Pirate's Alley is one of the most well-known places in Old New Orleans. (Courtesy of New Orleans News Company.)

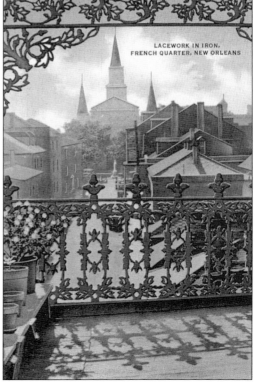

LACEWORK IN IRON. Here we see the rear of the St. Louis Cathedral from a balcony on Bourbon Street looking down Orleans. There is more beautiful ironwork in New Orleans than anywhere else in America. This delicate cast-iron pattern is characteristic of the best in the city. (Courtesy of A. Hirschwitz.)

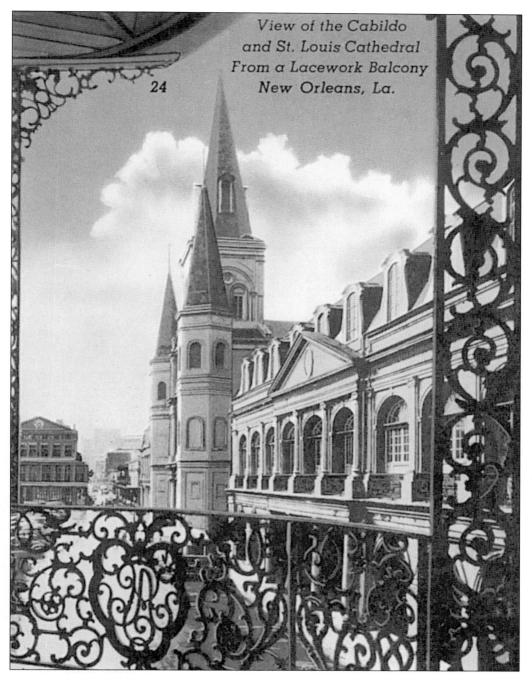

View of the Cabildo
and St. Louis Cathedral
From a Lacework Balcony
New Orleans, La.

24

THE CABILDO AND THE ST. LOUIS CATHEDRAL. The St. Louis Cathedral is seen here from the second- story balcony of the Pontalba building on Chartres Street. This cast-iron balcony bears the interlaced initials "A & P," as seen here in the lower center of the image. The letters stand for the two families, Almonester and Pontalba. This was, reportedly, the first cast-iron balcony in New Orleans, and, along with the cast-iron fence at the Cornstalk Hotel, it is the most recognizable ironwork in the Crescent City. (Courtesy of Louisiana News Company.)

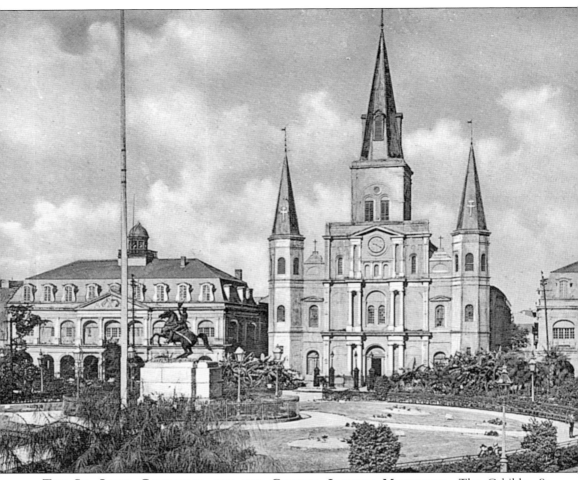

THE ST. LOUIS CATHEDRAL AND THE GENERAL JACKSON MONUMENT. The Cabildo, St. Louis Cathedral, Presbytere, and Jackson Statue, as seen in here in 1915, appear the same today, nearly 85 years later. This area, known as Jackson Square, is located on Decatur Street, and is ground zero for the French Quarter. The courtyard, or plaza, shown here in the foreground, was originally known as the Place d'Armes, and it has been the scene of many significant events in Louisiana history. It was here that America officially received the title from France, and General Lafayette was honored here in 1826. Originally a large dirt area, the Place d'Armes served as a parade and drill ground for French troops, as well as the place where criminals were executed. The massive and beautiful large iron gates and fence were added in 1851, and the area was renamed Jackson Square.

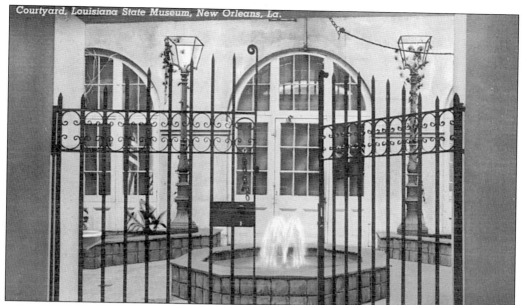

THE COURTYARD OF THE LOUISIANA STATE MUSEUM. This building, formerly known as the Presbytere, was completed in 1813 by the American government, although it is Spanish by design. It was originally known as Casa Curial, and, like the St. Louis Cathedral, was started by Don Almonester Y Roxas. Construction on the religious building was halted until the Cabildo was finished. A second story and a mansard roof were added later to match the Cabildo roof, which was added in 1847. The building was sold to the city in 1853, having never been used for the purpose for which it was designed, as the Presbytere. Today, this building, like the Cabildo, is owned by the Louisiana State Museum. (Courtesy of A. Hirschwitz.)

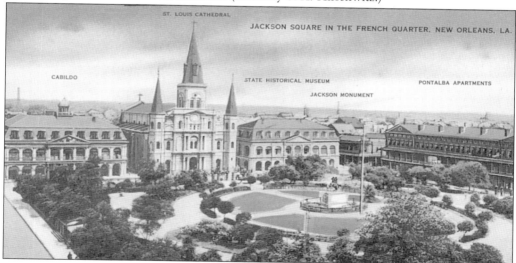

JACKSON SQUARE. This photograph, *c.* 1930s, shows the position of the buildings in Jackson Square. On the right is one of the Pontalba apartments. The Presbytere (the Louisiana State Museum) is the next major building on the left, followed by the St. Louis Cathedral, and finally, the Cabildo. In the foreground is Jackson Square, and to the left, but not seen in this picture, is the other Pontalba building.

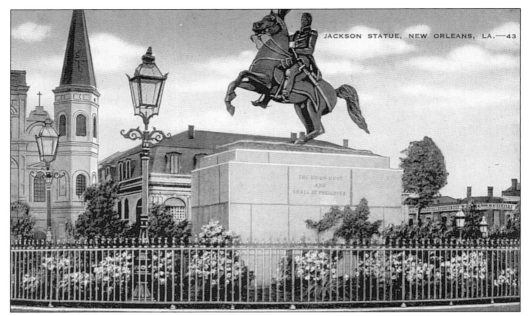

JACKSON STATUE. The Place d'Armes was renamed Jackson Square in 1851 in honor of Andrew Jackson, who had visited in 1840 and laid the cornerstone for a statue in his honor. This statue, by Clark Mills, was unveiled in 1856. There are two other exact castings: one is located in Nashville on the grounds of the Tennessee State Capitol Building; the other is in Washington, D.C.

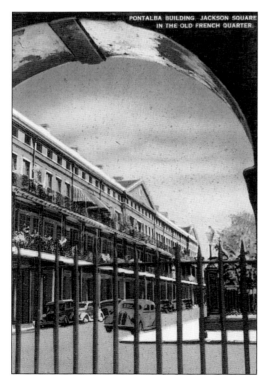

PONTALBA BUILDING JACKSON SQUARE
IN THE OLD FRENCH QUARTER

THE PONTALBA BUILDING. The Pontalba apartment buildings are situated on either side of Jackson Square. The buildings were originally designed by famous architect John Gallier, but they were finished by Samuel Stewart. This view shows one of the Pontalba buildings, as seen from the Presbytere.

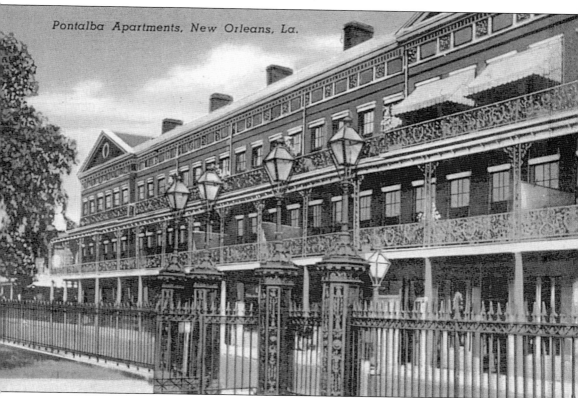

Pontalba Apartments, New Orleans, La.

THE PONTALBA APARTMENTS. The magnificent iron gates and fence, through which we see the Pontalba apartment building, were designed by Louis Pilie and added to the Place d'Armes in 1851. Note the graceful cast-iron railings on the second- and third-level balconies. These two near-identical Pontalba buildings were designed to house merchants on the ground-level floors, and there were residences on the second and third floors. This same configuration is in operation today. (Courtesy of Post Card Specialties, New Orleans.)

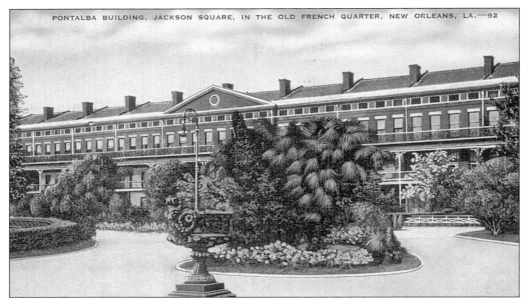

THE PONTALBA APARTMENT BUILDING. This view, dating from 1939, gives an indication of the three-story building's length. The two buildings, referred to as the Upper and Lower Pontalba buildings, were built for Micaela Almonester, the Baroness de Pontalba, who was possibly the most interesting woman in American history.

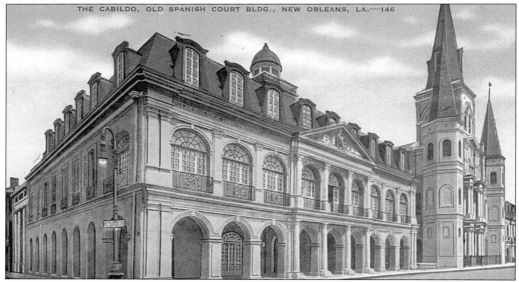

THE CABILDO OLD SPANISH COURT BUILDING. The Spanish Cabildo, as it was called, was built by Don Almonester Y Roxas in 1795 as a capitol building for the Spanish Colonial government. It is the third building to occupy the site. The Cabildo was, during its long history, owned by the Spanish, the French, and the Americans. It was in this building that Louisiana was transferred from Spain to France, and shortly thereafter, from France to America. Between 1803 and 1853, the Cabildo served as the New Orleans City Hall, and from 1853 until 1910 it housed the Louisiana Supreme Court. In 1911, the building was acquired by the Louisiana State Museum, and it is now open to the public.

THE STAIRWAY IN THE CABILDO. The Cabildo suffered a serious fire on May 11, 1988. The fire, started by a worker's torch, destroyed the cupola and much of the third floor, as well as many historical artifacts. People stood crying in Jackson Square as the flames spread. After an $8 million restoration, the Cabildo reopened on February 27, 1994. This picture of the Cabildo's stairway shows the graceful banister, with an interior view of the front gate, which faces Jackson Square. It was here, at the Cabildo, that the Marquis De Lafayette stayed in 1825 as a guest of the city. While New Orleans is generally thought to be French, most of the architecture in the French Quarter is actually Spanish, due to the fact that Spain owned Louisiana from 1762 to 1800. Fires destroyed most of the city in 1788 and 1794.

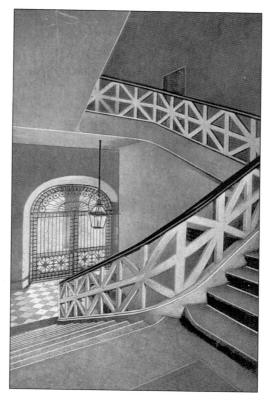

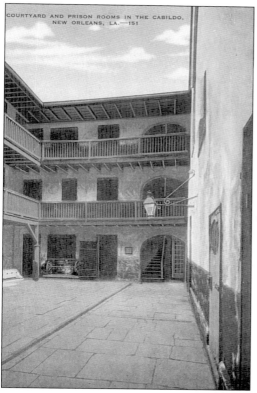

THE COURTYARD AND PRISON ROOMS IN THE CABILDO. In its day, the Cabildo served as a jail. It was here that the Jean Lafitte, the pirate, was temporarily incarcerated after his capture by the Americans. It is said that the open cell seen on the first level is where he was kept. (Courtesy of New Orleans News Company.)

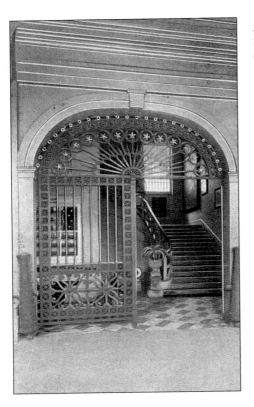

AN OLD GATE AND THE STAIRWAY OF THE SPANISH CABILDO. The beautiful wrought-iron entrance to the Cabildo is seen here.

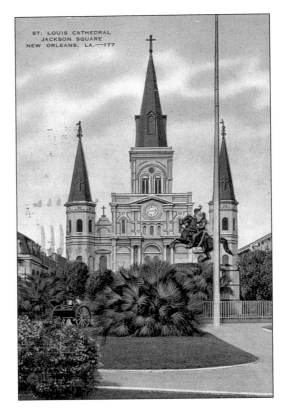

THE ST. LOUIS CATHEDRAL, JACKSON SQUARE. The St. Louis Cathedral is the centerpiece of Jackson Square. It was originally built in 1718 by Don Almonaster Y Roxas, and was rebuilt in 1720. The present building was erected in 1794. The spires, seen at either side of the cathedral, were originally smaller domes. To the rear of the cathedral is St. Anthony's Garden, a refreshing courtyard that is bordered by Royal Street.

44

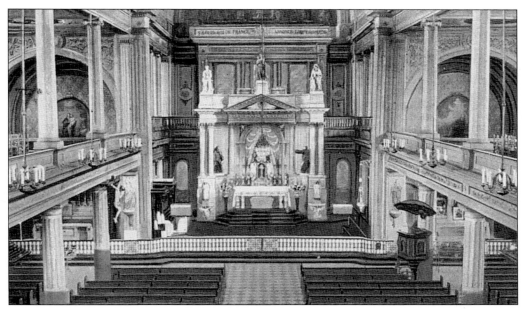

THE INTERIOR OF THE ST. LOUIS CATHEDRAL. The St. Louis Cathedral is probably the most well-known church in America, and certainly the most photographed. Its elegant interior features a magnificent pipe-organ, stained-glass windows, and colorful murals. The tombs of the Marignys lie beneath the floor in front of the altar.

A STAINED-GLASS WINDOW. This stained glass window, one of many in the St. Louis Cathedral, depicts important events in the life of St. Louis, including his death.

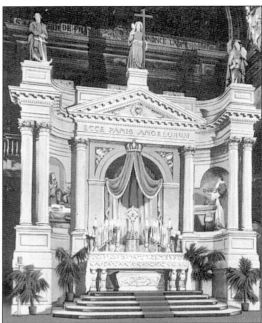

THE MAIN ALTAR. The main altar of the cathedral is impressive in its own right as an architectural work of beauty. In 1964, the St. Louis Cathedral was up-graded in status by Pope Paul, who declared it to be a basilica.

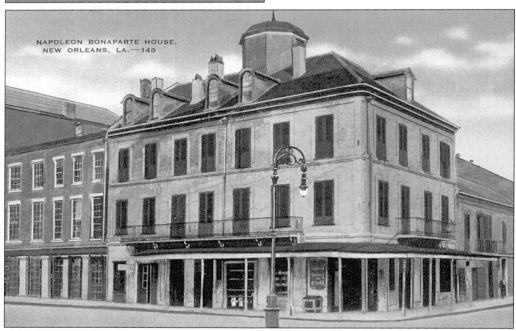

THE NAPOLEON BONAPARTE HOUSE. New Orleans, ever French, offered sanctuary to Napoleon after his escape from Elba Island. The Napoleon House, built in 1814, was allegedly prepared for the emperor at the corner of St. Louis and Chartres, and a ship to rescue him from St. Helena was supposedly outfitted at the expense of some wealthy New Orleanians. Napoleon died, however, just a few days before the ship's departure. Today, the Napoleon House is a famous restaurant and bar, and looks similar to the way it does here. It is the former residence of New Orleans mayor Nicholas Girod, who served from 1812 until 1815.

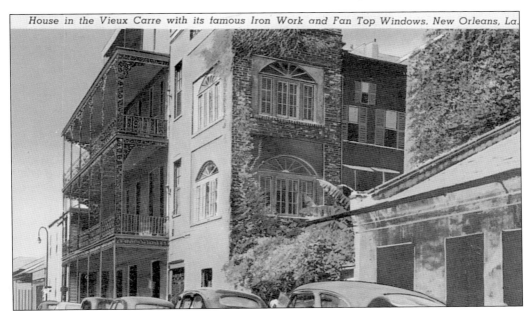

House in the Vieux Carre with its famous Iron Work and Fan Top Windows. New Orleans, La.

A HOUSE IN THE VIEUX CARRE. Ornamental fan windows are frequently seen in French Quarter homes. This scene is from the 1940s, judging from the cars parked at the curb.

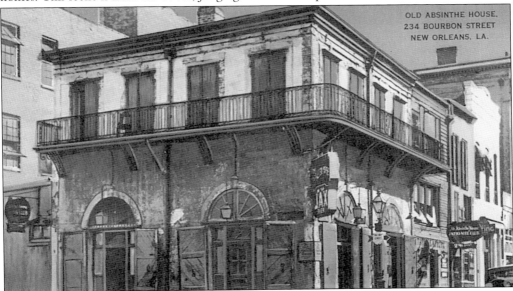

OLD ABSINTHE HOUSE,
234 BOURBON STREET
NEW ORLEANS, LA.

THE OLD ABSINTHE HOUSE. The Old Absinthe House, built in 1798, is located at 240 Bourbon Street, and is a part of French Quarter history. It is seen here in the late 1920s, prior to its restoration. For years, the house was the subject of tall tales and legends, many of which involved infamous pirate Jean Lafitte. The building was originally a residence and store for Francisco Juncadello, a Spanish immigrant whose heirs still own the building. When it became a bar in the late 1860s, it also sold absinthe. At length, absinthe was outlawed, prohibition became the law of the land, the famous interior bar was sold, and the place went downhill. After hosting several other businesses, the Old Absinthe House became an immensely successful enterprise under the guidance of Owen Brennan.

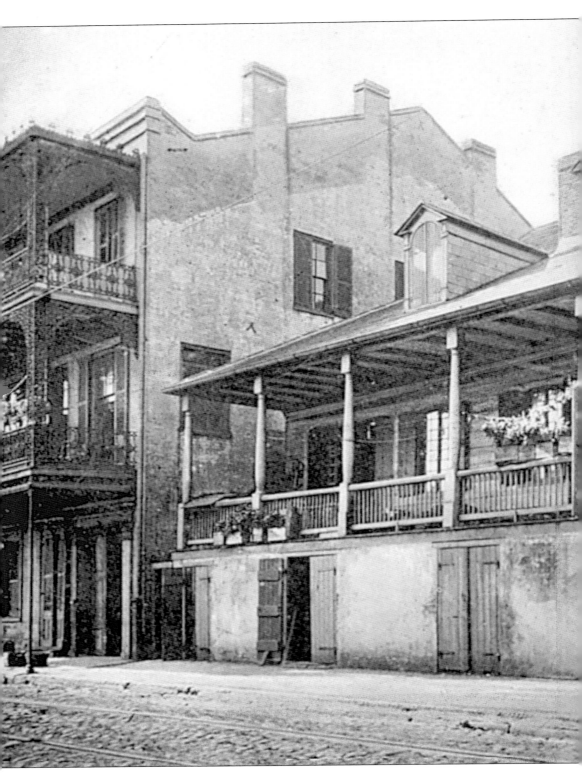

MADAME JOHN'S LEGACY. This "raised cottage" house, located at 623 Dumaine Street, is one of the most photographed buildings in the Vieux Carre. It is also reported to be the oldest building in the Mississippi Valley. The original 1726 building served as a residence for French sea captain Jean Pascal and his family, prior to Pascal's murder by the Natchez Indians in a 1729 massacre. The house was also supposedly rebuilt in 1788 for Spaniard Manuel Lanzos, after the original house burned down, but this cannot be confirmed. What is known for certain is that the house was immortalized by late-19th-century American (New Orleans) writer George Washington Cable, in a series of stories about the Creoles. Madame John, a free woman of color and mistress of a Frenchman, received the house from her former master upon his death. The house was donated to the Louisiana State Museum in 1947, but it is not open to the public.

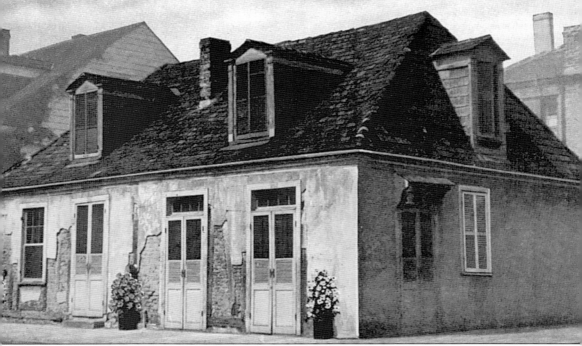

THE BLACKSMITH SHOP OF JEAN LAFITTE. According to legend, this house, at 941 Bourbon Street, was the blacksmith shop of pirate Jean Lafitte (1780–1825.) Despite his illegal activities, Lafitte was pardoned by the United States, due to his efforts at the Battle of New Orleans in January 1815. Lafitte had set up his headquarters at Barataria, south of New Orleans, and from there he operated a big business selling slaves and contraband. At one time, Governor Claiborne had placed a reward for his capture. According to legend, Lafitte countered by offering a larger amount for the capture of Claiborne. Be that as it may, it was Claiborne whom Lafitte approached with information about the British. With Old Hickory, pirates, and armed locals, the Americans won the Battle of New Orleans with 7 American casualties compared to 2,000 British. This building has served in many capacities throughout its long history, and like many other French Quarter buildings, was, at one time, a bar.

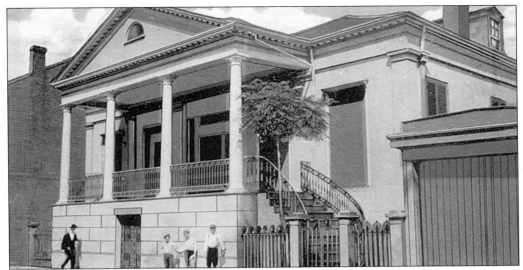

THE GENERAL BEAUREGARD RESIDENCE. This house, located at 1113 Chartres Street and dating from 1836, was the birthplace of chess champion Paul Morphy (1837–1884). It was originally owned by the chess master's grandfather, Joseph LeCarpentier. Paul Morphy's father, Judge Alonzo Morphy, at one time owned the house at 417 Royal, which is now famous as the home of Brennan's, one of New Orleans' favorite restaurants. Confederate General P.G.T. Beauregard (1818–1883) was a West Point graduate born in New Orleans who became famous when he ordered the first shot fired at Fort Sumter in the Civil War. He lived here, at the pictured building, for a brief time after the war, and the house consequently came to be known as the Beauregard House. A statue honoring Gen. Beauregard is located on Esplanade, at the entrance to City Park.

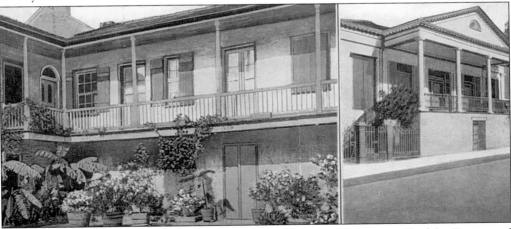

THE COURTYARD OF THE BEAUREGARD HOUSE. Here, we see the courtyard of the Beauregard House, now known as the Beauregard-Keyes House. Famous American novelist Francis Parkinson Keyes (1885–1970), pronounced "Kize" by northerners, bought and restored this house, possibly saving it from oblivion. Keyes also bought and demolished the building that was pictured to the left of the house in the previous photo, and erected a second walled courtyard and garden. The courtyard and former slaves' quarters, pictured at the left of this image, are located behind the main house. This area was her favorite place and the site where many of her books were written. Today, the house is open to the public for tours.

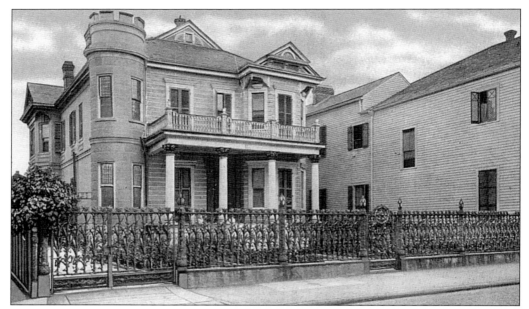

ORNAMENTAL IRON AT THE CORNSTALK HOTEL. The Cornstalk Hotel, located at 915 Royal Street, possesses probably the most famous ironwork in New Orleans. The fence, approximately 50 feet long, has a cornstalk motif, with gateposts topped by a bouquet of corn ears resting atop pumpkins. The house, now a hotel, was at one time occupied by French-born Judge Francis Xavier Martin (1762–1846), the first Chief Justice of the Louisiana Supreme Court.

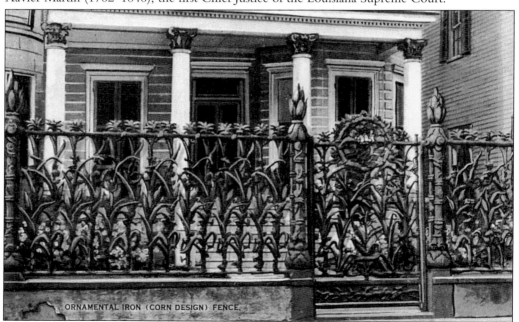

ORNAMENTAL IRON (CORN DESIGN) FENCE.

ORNAMENTAL IRON. While speculations as to the date of this fence vary, it is generally agreed that it was cast sometime between 1830 and 1860. An identical fence, which was cast by the Philadelphia foundry of Wood & Perot, surrounds the magnificent Garden District mansion of Colonel Robert Short at 1448 Fourth Street.

Three

RESTAURANTS

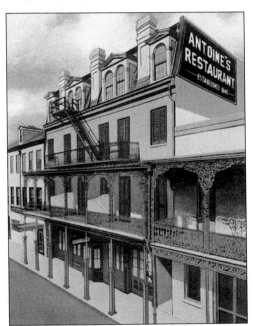

ANTOINE'S RESTAURANT. Located at 713 St. Peter Street, Antoine's is one of America's most famous restaurants. It was founded in 1840 by Antoine Alciatore, who came to New Orleans from Marseilles, France, that same year. Several world-famous dishes have originated here, including "Oysters Rockefeller" and "Pompano en Papillote." Ceiling fans spin slowly overhead as diners feast on some of New Orleans' best cuisine. Since the restaurant's opening, the internationally famous from all over the world have dined here. (Courtesy of Alphonse Goldsmith, New Orleans.)

New Orleans has, some would say, the best cuisine in America, whether it's French, Creole, or Cajun. Today, the Crescent City boasts renowned chefs such as Emeril and K-Paul, restaurants like Arnaud's, Antoine's, and the Commander's Palace, and cajun cooks in little out-of-the-way places.

THE HOLSUM CAFETERIA. The Holsum Cafeteria was located at 712–720 Gravier Street, opposite the St. Charles Hotel, and it specialized in "truly economical excellent food." It was touted as "New Orleans' finest" and one of "America's best." The Holsum Cafeteria is now gone, as is the St. Charles Hotel.

PAT O'BRIEN'S COCKTAIL ROOM. Pat O'Brien's is probably the most famous bar in New Orleans. Like everything else in the French Quarter, and most of New Orleans, there is some historical significance to this building. The former residence, located at 718 St. Peter Street, was built in 1792, and was the site of the first Spanish theatre in America. Today, the cocktail room looks the same as when this photograph was taken. The route through the building is also the same, through the entrance, under a row of crossed antique rifles arched above and, there to the right, is the cocktail room. It is seldom empty, as pictured here. Instead, there is piano music and an abundance of laughter and spirited conversation, not to mention plenty of New Orleans' most famous drink, "The Hurricane."

THE COURTYARD AT PAT O'BRIEN'S. The courtyard at Pat O'Brien's is one of the most relaxing places in the French Quarter, and a perennial favorite for celebrities, tourists, and locals alike. The walled courtyard's most noteworthy feature is the large fountain at its center. The fountain has roaring gas-fed flames surrounded by tall water-jets, all filtered with colored lights. The flames, blowing in the gentle breezes on the patio and mixing with the spraying waters of the fountain, are most intriguing.

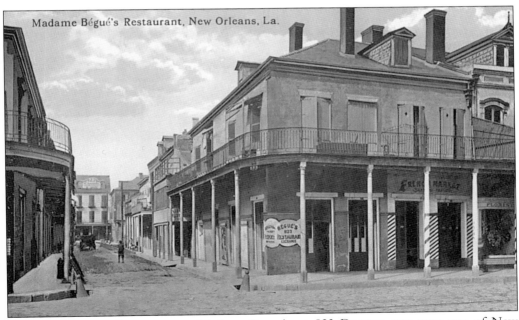

Madame Bégué's Restaurant, New Orleans, La.

MADAME BEGUE'S RESTAURANT. Madame Begue's, at 823 Decatur, was once one of New Orleans' most famous restaurants, but it is gone now. The building remains, however, and is the home of Tujague's, a respected restaurant in its own right. The restaurant, in its incarnation as Madame Begue's, was featured in the movie adaptation of Edna Ferber's novel *Saratoga Trunk*, starring Gary Cooper and Ingrid Bergman.

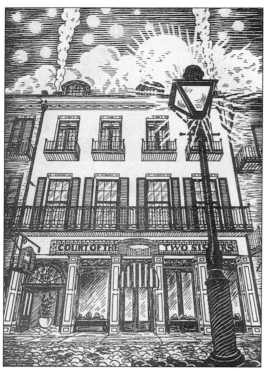

THE COURT OF THE TWO SISTERS, ROYAL STREET. The Court of the Two Sisters, located at 613 Royal Street, was built in 1832 and is recognized as having one of the most beautiful, and largest, courtyards in the entire Quarter. Its 200-year-old "Charm Gates" are said to be lucky if you touch them. The Court of the Two Sisters Restaurant is one of the city's most famous, and it offers a spectacular Sunday brunch. This fanciful lithograph of the restaurant was taken from *The Bachelor in New Orleans*, a 1942 classic published by Bob Riley.

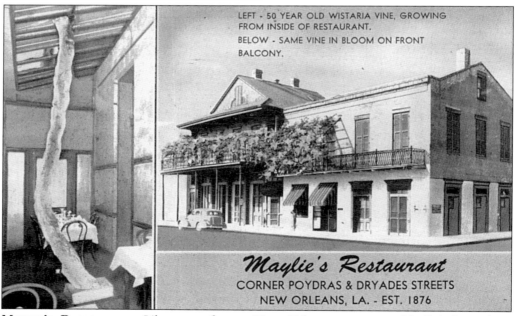

MAYLIE'S RESTAURANT. Like many famous New Orleans restaurants, Maylie's has a long history. The French restaurant was established by the Maylie and Esparbe families in 1876 at the corner of Poydras and Dryades Streets. This New Orleans institution was noted for its gigantic wisteria vine that grew from the floor of the restaurant, through the roof, and out onto the balcony.

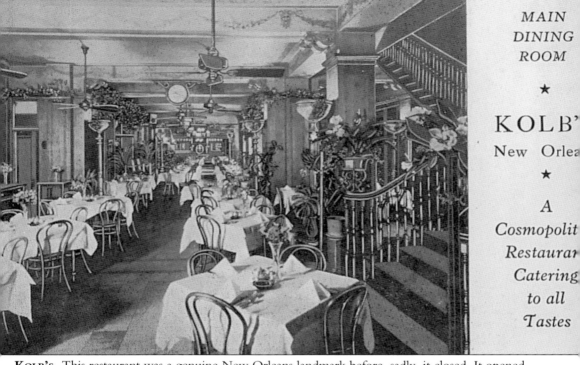

MAIN
DINING
ROOM

★

KOLB'

New Orlea

★

A
Cosmopolit
Restaurar
Catering
to all
Tastes

KOLB'S. This restaurant was a genuine New Orleans landmark before, sadly, it closed. It opened in 1899, and, for nearly a century, served epicurean dishes of all nationalities, although it was most famous for its German and Bavarian specialities. Overhead, in the main dining room, belt-driven ceiling fans were connected to each other, with the main drive belt appearing to be hand cranked by a life-size German figure, dressed in traditional Bavarian attire.

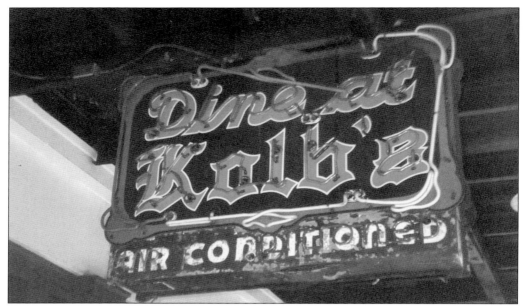

KOLB'S SIGN. The entire front of the famous restaurant is now boarded up, but the neon sign, still suspended outside, reminds passersby of this New Orleans restaurant's former glory. It is strange that a restaurant or business can last for a hundred years or more as a New Orleans landmark and then go out of business with little notice, or simply close its doors for good. Madame Begue's, Kolb's, and the Jax Brewery immediately come to mind.

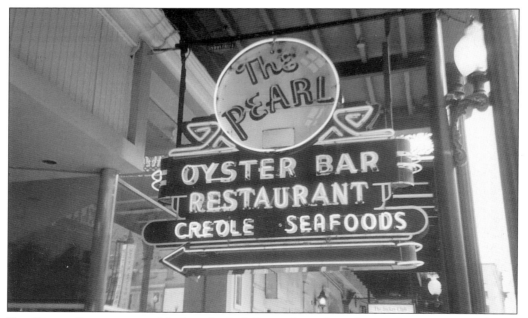

THE PEARL. Raw oysters and fresh seafood of all types have always been a Crescent City tradition. Fried soft-shell crabs, boiled crawdads, and Gulf shrimp are just a few of the culinary delights available. This sign, located over the doorway at 119 St. Charles Street, announces the presence of The Pearl, a New Orleans tradition.

Four

THE CITY

A SOUVENIR FOLDER OF NEW ORLEANS. This souvenir folder of New Orleans shows Canal Street at night, *c.* 1944. Other than the addition of some taller buildings in the bordering Business District, very little has changed in almost the past 60 years, and Canal Street remains the city's main downtown business thoroughfare.

Many people think of New Orleans solely as the French Quarter. It is actually a large, vibrant city with a busy seaport, and it is a financial, trade, and antiques center, with many educational institutions and hospitals.

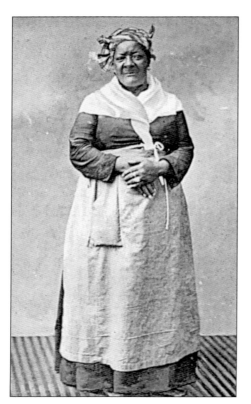

A CREOLE NURSE. In the South, after the Civil War, labor was cheap, and newly freed former slaves had to work to survive. Consequently, most moderate-to-high-income families had black maids. This was a widespread practice that continued throughout the 1960s.

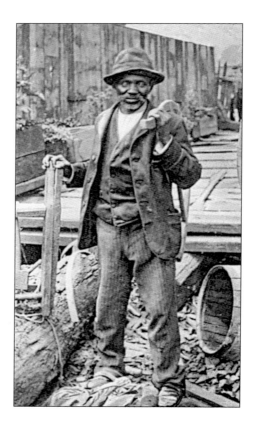

A BLACK WOOD SAWYER. When the Civil War was over and the slaves had been freed, life for most of them was rough. For the most part, individuals generally continued performing the same type of work they had done on the plantations.

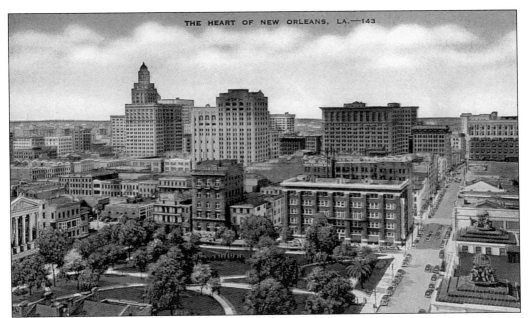

THE HEART OF NEW ORLEANS. This scene shows the original city hall (at the lower left of the picture). Built between 1845 and 1853 at 545 St. Charles Avenue, it faces one of the city's many beautiful public parks. It was designed by James Gallier Sr., the foremost Greek Revival architect in America at the time and the man responsible for some of Louisiana's most remarkable buildings. It served as city hall until 1957, when it was renamed Gallier Hall in the architect's honor. (Courtesy of New Orleans News Company.)

A Scenic Spot in the Heart of the Business Section
New Orleans, La.

"A SCENIC SPOT IN THE HEART OF THE BUSINESS SECTION." This postcard shows the magnificent entrance to the former Southern Railway terminal building, which was, prior to its destruction, located on Canal Street.

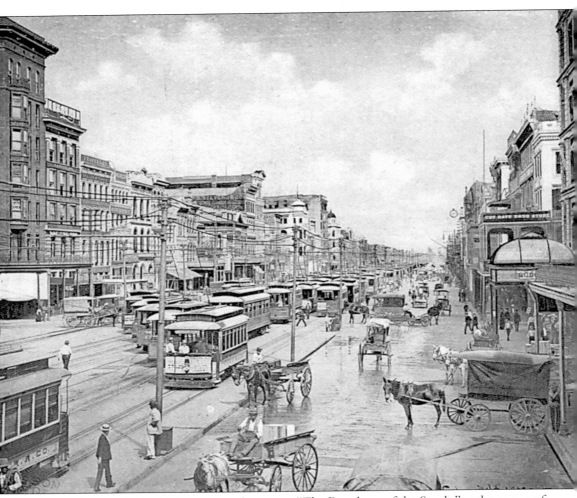

CANAL STREET, 1901. This street was known as "The Broadway of the South," and was one of the widest streets in the world. At the time of this photograph, it had five sets of streetcar tracks and two lanes for carriages and horse-drawn wagons. Streetcars still run along Canal Street and out of St. Charles Street into the fabulous Garden District.

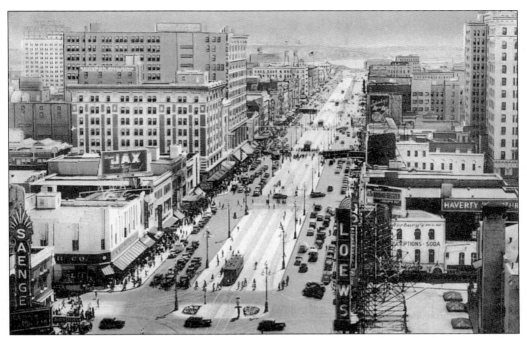

CANAL STREET, PROBABLY IN THE LATE 1920s. This street is, and always has been in modern times, the Commercial and Business District's main thoroughfare. In this scene pedestrians line the sidewalks on their way to and from various activities. Prominent to the left side of this image, located atop a building, is a large sign advertising Jax Beer. The Jackson Brewery, now restored as a shopping mall, was one of several significant breweries in the city's history, along with the Falstaff and Regal Breweries. Today, Dixie and Abita beers are still brewed in the Crescent City.

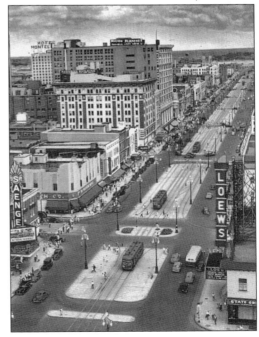

CANAL STREET. This tall, narrow view of Canal Street shows the 1927 Saenger Theatre to the left, and the Loews across the street on the right. Further down the street on the left are the Audubon building and Maison Blanche. (Courtesy of A. Hirschwitz.)

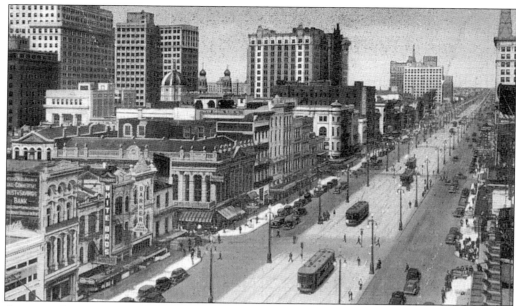

ANOTHER VIEW OF CANAL STREET FROM ABOVE. This view of Canal Street, looking west, shows the central Business District to the left, which is situated between Canal Street and Poydras.

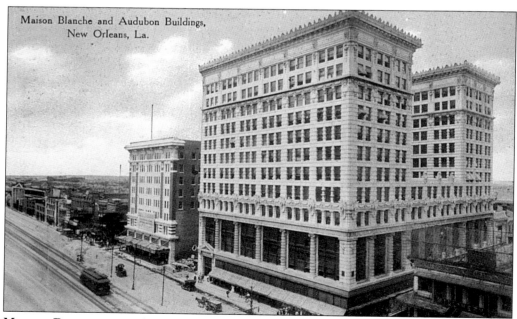

Maison Blanche and Audubon Buildings, New Orleans, La.

MAISON BLANCHE AND AUDUBON BUILDINGS. Maison Blanche is seen here on the right in 1910. It was built between 1906 and 1907, and has long been New Orleans' most famous department store.

Liberty Place, foot of Canal Street, New Orleans, La.

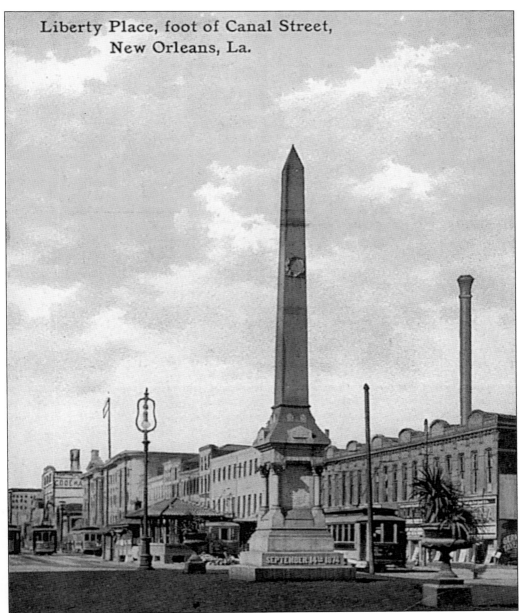

LIBERTY PLACE AT THE FOOT OF CANAL STREET. Certainly one of the most important of the many monuments in New Orleans is the Liberty Monument. This granite obelisk was erected by the Crescent White League at the foot of Canal Street in 1891, in commemoration of the 1874 Battle of Liberty Place. During this Reconstruction-era battle, the White League attacked the biracial and carpetbagging Metropolitan Police department. Twenty-five people were killed and more than a hundred were wounded in the fighting. Grant sent troops to aid the Republican puppet regime. In 1990, the city government removed the statue, allegedly for street work. David Duke's followers filed and won a suit to have the statue returned. The statue was relocated to an inconspicuous site, and a different, more ethnically and socially "correct," plaque was affixed.

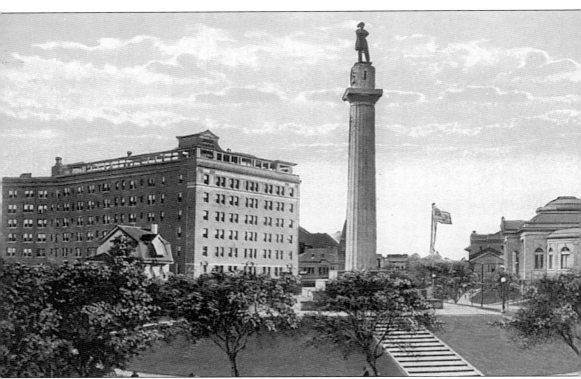

Lee Circle, the Bienville Hotel, and the Public Library. New Orleans remains an unreconstructed city, a place that values its traditions, history, and individuality. Among those revered are the heroes of the Confederacy. This monument to Confederate Gen. Robert E. Lee was erected in 1884, sponsored by the Robert E. Lee Monumental Association, and dedicated on Washington's birthday. It is one of many monuments to Confederate heroes placed throughout the city. The 16.5-foot bronze statue of Robert E. Lee, facing St. Charles Avenue, stands atop a 60-foot-tall marble column with a Doric capitol. Also pictured are the former Bienville Hotel and the Carnegie Library. This area was known as Tivoli Circle prior to the erection of the Lee Monument.

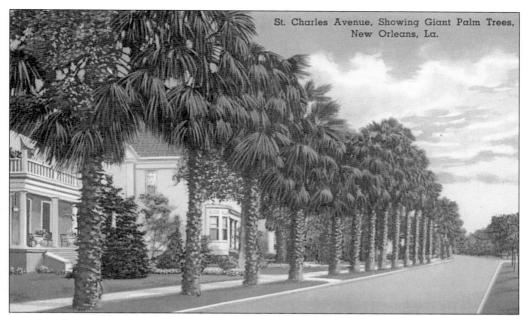

St. Charles Avenue, Showing Giant Palm Trees, New Orleans, La.

St. Charles Avenue and Giant Palm Trees. St. Charles Avenue is the main thoroughfare of the area known as the Garden District. New Orleans' wealthiest residents built many of the most elegant houses ever seen in America here, some of which still remain. The mansions along St. Charles represent the epitome of classical New Orleans residential architecture.

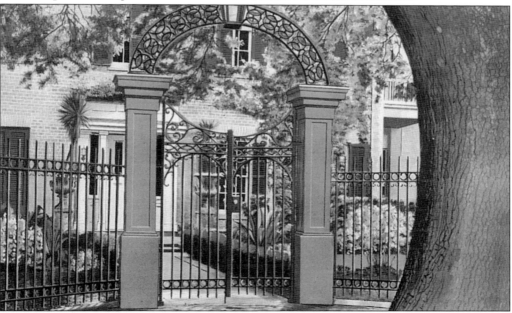

A Beautiful Entrance in the Garden District. Public parks, private gardens, and courtyards have always been an integral part of New Orleans social life, whether for entertaining or quiet personal reflection. This gated entrance to a Garden District mansion, and the manicured lawn and foliage surrounding the house, clearly illustrate why the area is called the Garden District. (Courtesy of Louisiana News Company.)

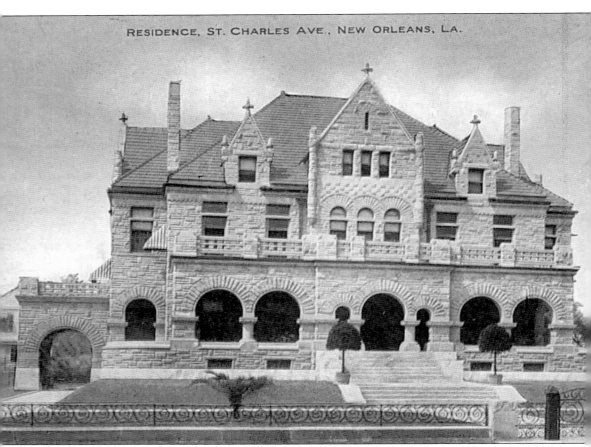

A Residence on St. Charles Avenue. This massive cut-stone mansion, known as the Brown–Villere House, was built in 1905 in St. Charles Avenue. Architecturally, it is in the style known as Richardsonian Romanesque. This particular house, like many other houses in the Garden District, is indicative of the wealth, extravagance, and excess that have always characterized much of New Orleans architecture.

Five

MARDI GRAS
AND SOCIAL CLUBS

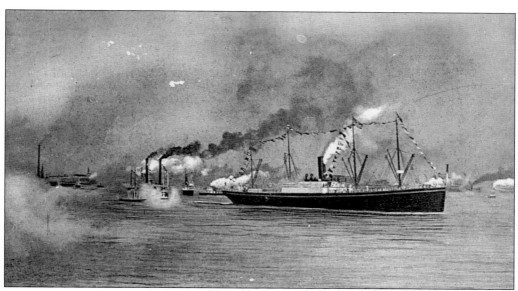

THE ARRIVAL OF REX. The krewe of Rex, King of Carnival, was organized in 1872, and his parade always takes place on Mardi Gras Day. Rex first arrived by steamboat in 1874, and the tradition of a river parade continues to this day.

Carnival, or Mardi Gras, is the major social event of the calendar year in New Orleans. It is a time of revelry, excitement, and is a generally acceptable excuse for going wild. From the famous Mardi Gras "krewes" like Proteus, Momus, and Comus, to the exclusive private country and golf clubs, New Orleans has always offered its citizens a rich array of social organizations and activities.

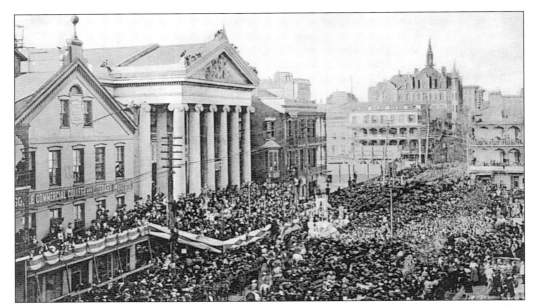

THE RECEPTION OF REX AT CITY HALL. Mardi Gras, literally meaning "Fat Tuesday," is celebrated the day before Ash Wednesday, which is the start of the 40-day season of Lent, during which Catholics are supposed to fast and do penance. Though the first New Orleans Mardi Gras Parade was held in 1837, and the first float made its appearance in 1839, Mardi Gras in New Orleans predates these first organized efforts. In 1699, on Shrove Tuesday, the day before Ash Wednesday, Iberville and Bienville discovered a bayou, and named it "Mardi Gras Bayou" in honor of the day.

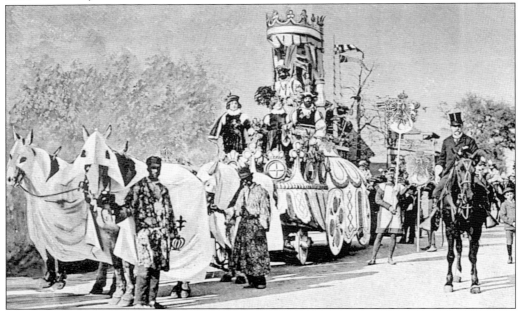

THE REX FLOAT, MARDI GRAS. Although Rex is but one of the many carnival krewes, it seems to be the most photographed. Others include The Twelfth Night Revelers, The Elves of Oberon, Mithras, Zulu, Hermes, Bacchus, and Endymion.

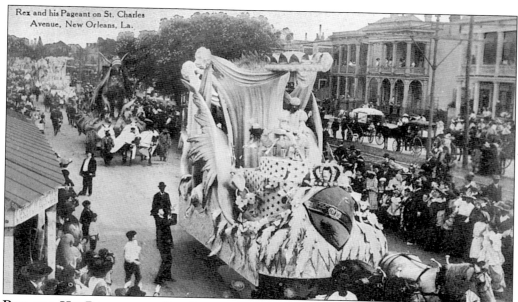

REX AND HIS PAGEANT ON ST. CHARLES STREET. This photograph was taken around 1900. Note the absence of automobiles and the horses pulling the float. While there are many different krewes, not all have parades. Some just have private balls, while others conduct public parades and private balls. The crown at the front of this float indicates that the float belongs to Rex. The small, simple display seems almost primitive in comparison to the elaborate and exotic floats in use today.

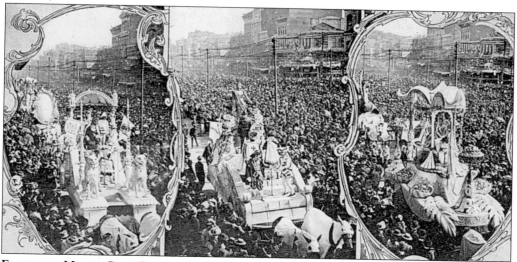

FLOATS OF MARDI GRAS PROCESSION. These early horse-drawn floats again show the festival as it appeared at the turn of the century. In addition to the changes in the size, number, and types of floats, there have been other changes to Mardi Gras as well. In 1992, in a misdirected effort to block the rights of private clubs to exist, the city council passed a measure restricting the use of public streets solely to parading groups, which had no restrictions on membership. Three of the oldest krewes, Momus (1872), Comus (1857), and Proteus, understandably withdrew from the parade in protest They continue to exercise their rights of free association by conducting private balls.

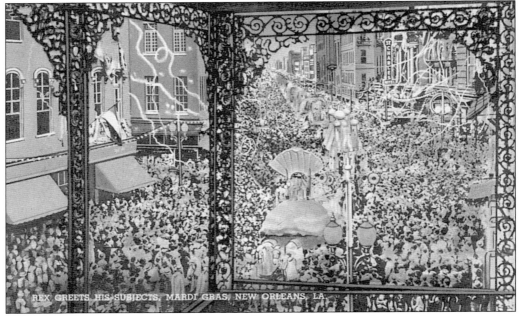

REX GREETS HIS SUBJECTS. This old postcard photo, taken from a balcony, shows the carnival procession as it moved down St. Charles Street into Canal Street. (Courtesy of A. Hirschwitz, New Orleans.)

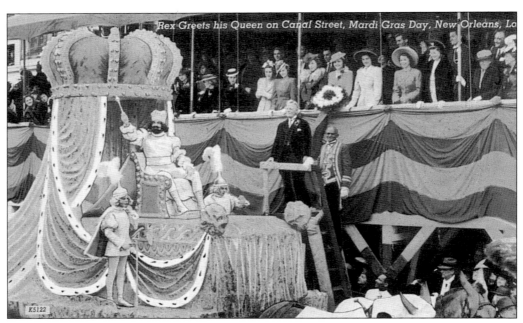

REX GREETS HIS QUEEN. The tradition of Mardi Gras Queen is a later addition to the festivities. Exotic balls and parties are conducted each year, well in advance of the actual Mardi Gras.

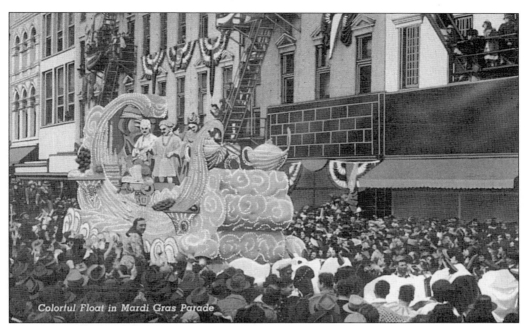

Colorful Float in Mardi Gras Parade

A Colorful Float in a Mardi Gras Parade. Crowds fill the streets at each parade during the carnival, or Mardi Gras, each year in February.

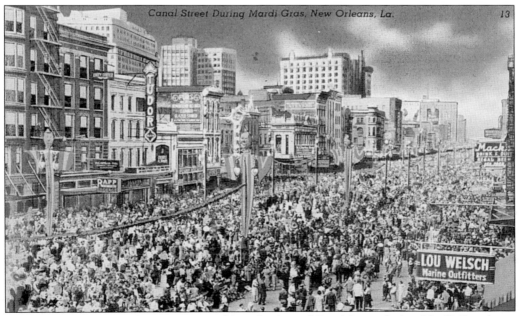

Canal Street during Mardi Gras. This early view of Canal Street during Mardi Gras shows the city's main thoroughfare completely covered with pedestrian traffic. Today, Mardi Gras is bigger than ever, but there are now also other annual festivals that draw similar-sized crowds. The Jazz and Heritage Festival is another major attraction each year.

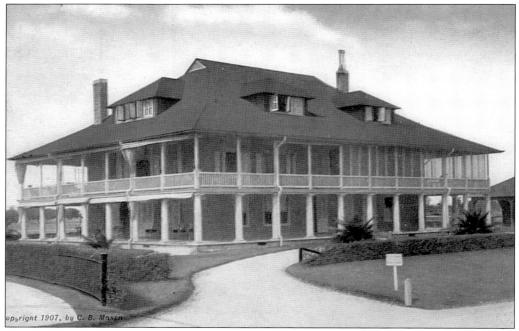

THE COUNTRY CLUB OF NEW ORLEANS. The beautiful late-1790s house in this 1907 photograph was known as the Country Club of New Orleans. It was not the same organization as the later New Orleans Country Club, pictured below. Both clubs existed at the same time, between 1915 and 1917. The building in this picture was located in City Park, and burned in 1917. Some of its members then affiliated with the New Orleans Country Club.

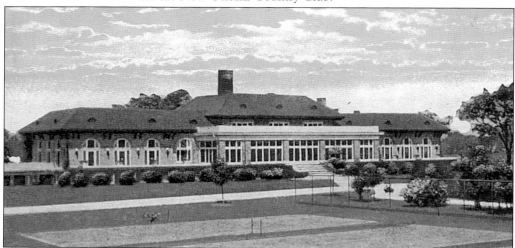

THE NEW ORLEANS COUNTRY CLUB. The New Orleans Country Club is located on Pontchartrain Boulevard, close to Metarie. This organization formally opened on May 7, 1915, and was housed in the large building pictured here. On Halloween night, 1921, this magnificent building also burned. The club's manager, Leigh Carroll, was dressed and preparing to go to the club when he received news of the fire. He hastened to the scene and instructed firefighters to let the building burn if necessary, but to use their water to save the 300-year-old trees, which were symbols of the club. The building was replaced, but the original trees remain.

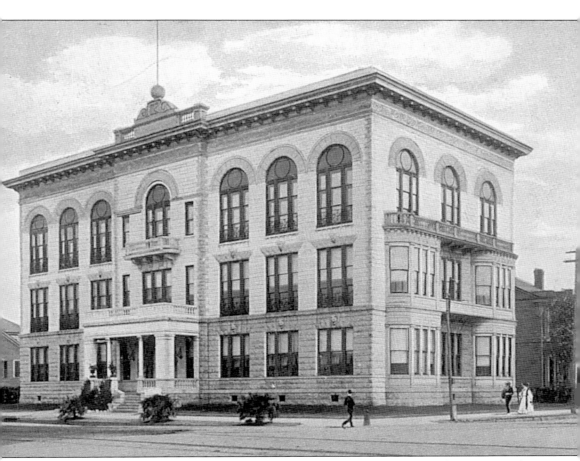

THE HARMONY CLUB. The Harmony Club, as seen in this *c.* 1900 photograph, was erected in 1896 as a Jewish social club on St. Charles Avenue. The impressive three-story building was built of Georgia marble, was elegantly furnished, and boasted a large ballroom and stage on the third floor. It eventually became a YMCA, followed by offices for Standard Oil of Louisiana, and it was finally demolished in the 1950s.

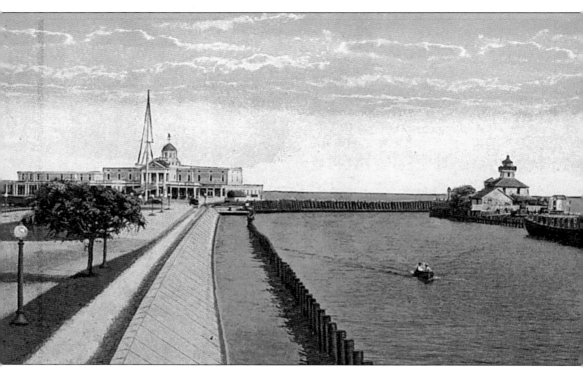

THE SOUTHERN YACHT CLUB. The Southern Yacht Club was a unique building, built on pilings in the shallow waters of Lake Pontchartrain in 1878. The lake has always been a favorite place for all watersports.

Six

HOTELS AND MOTELS

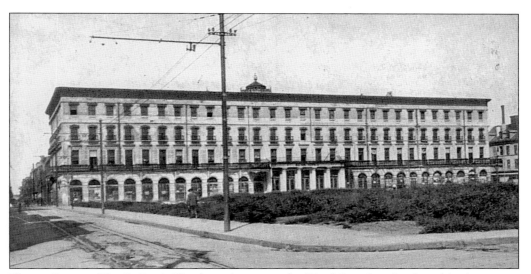

HOTEL ROYAL. The St. Louis Hotel was known as the Hotel Royal at the time this picture was taken in 1907, but its roots extend back far beyond that date. It opened in January 1835, before its completion, at the intersection of St. Louis and Chartres in the French Quarter. It was the hotel of choice prior to the Civil War. In 1874, the building was leased to the state and was used as the capitol, and it was retained by the state until 1882. It was, perhaps, the finest hotel ever seen in New Orleans. It was demolished in 1915.

No place in America, with the possible exception of New York City, has had better or more magnificent hotels than New Orleans. The almost unbelievable St. Louis and St. Charles Hotels, built before the Civil War, were followed by hotels like the Grunewald, the Roosevelt, the De Soto, and others following Reconstruction. After World War II, during the 1950s, and during the 1960s economic boom, roadside motels and tourist courts sprang up all over America, and New Orleans had its share. Today, the Crescent City has its grand hotels, as well as its small, intimate French Quarter hideaways.

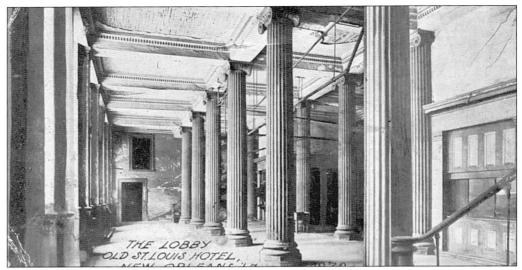

THE LOBBY OF THE OLD ST. LOUIS HOTEL. By the time this photograph of the St. Louis Hotel lobby was taken, the hotel appears to have been abandoned. And yet, through this lobby of the hotel passed the elite of New Orleans society. Of the many great architectural losses the city of New Orleans has suffered, including those caused by fires and hurricanes, none are more distressing than the intentional destruction of buildings like the St. Louis Hotel, the St. Charles Hotel, the Southern Railway terminal, and many others. It is ironic that many Americans come to New Orleans and other cities for the ambiance created by great architecture, when at the same time most of the nation seems intent on the destruction of historical architecture as fast as possible.

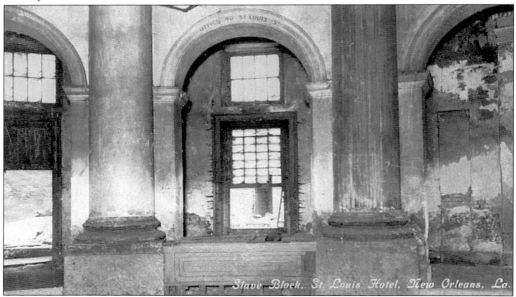

THE SLAVE BLOCK AT THE ST. LOUIS HOTEL. The elegant St. Louis Hotel, which replaced an earlier trade and exchange center at the same location, was designed with a first floor which contained a domed rotunda, reported to have been the most beautiful in America. It was here, in the midst of these elegant settings, that slaves were bought and sold.

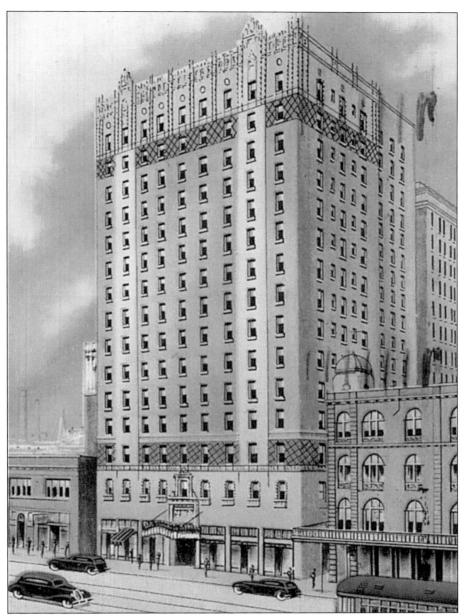

THE ROOSEVELT HOTEL. The 750-room Roosevelt Hotel, located at 123 Baronne Street and known as "The Pride of the South," is pictured in this 1937 postcard, which proclaims it as being the "largest and finest hotel in the South." The hotel was named after President Theodore Roosevelt in 1923, and it became the first hotel in the South to have more than 100 air-conditioned rooms. Today, the Roosevelt Hotel consists of several buildings, including the second Grunewald Hotel building. Since 1965, it has been called the Fairmont. It still retains its ornate gold-trimmed lobby and Sazerac Bar, with murals created by Paul Nina in 1949. In addition, the hotel also has a pool, tennis courts and restaurants. The hotel, in its days as the Roosevelt, was a New Orleans business and social center, and was a popular hangout for Governor Huey Long.

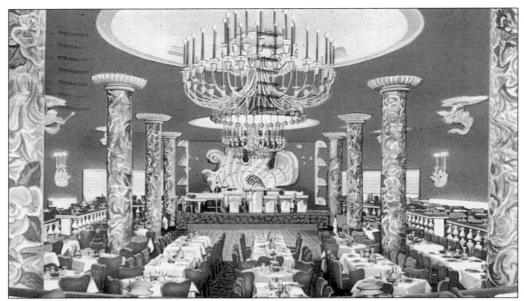

THE BLUE ROOM AT THE ROOSEVELT. By the time this postcard was sent in 1960, the Roosevelt Hotel proudly claimed to be "A 100% Air Conditioned Hotel." The elaborate Blue Room was one of the South's finest dinner and supper clubs, featuring music by the nation's most outstanding dance bands, and a superb twice-nightly "floor show." The Blue Room still exists today, but it is used primarily for special occasions.

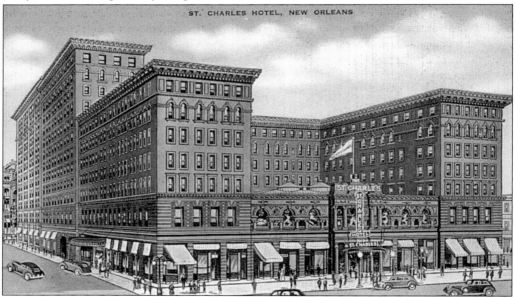

THE ST. CHARLES HOTEL. The third St. Charles Hotel was erected on the site of the first two in 1896, and though it lacked the exterior grace of its forerunners, it was one of New Orleans' most elegant hotels and social centers. Its huge open lobby represented the finest in Greek Revival architecture, and surviving interior photos show an incredibly ornate wrought-iron banister and elevator. This postcard, *c.* late 1930s, shows the hotel at its zenith. Sadly, the building was demolished in 1974, and the space is currently occupied by a parking lot.

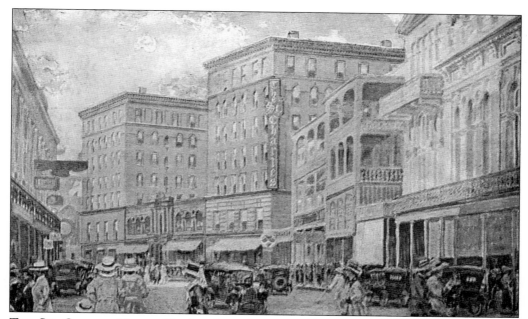

THE ST. CHARLES HOTEL. Fire has always been a problem in New Orleans, particularly with hotels. The first St. Charles Hotel burned to the ground in 1851, and the second succumbed to flames in 1894. The third St. Charles is seen here, in its 1920s setting, in a painting that hung in the lobby. The 1,000-guest hotel was, at one time, a part of the Dinkler Hotel Company, who were also operators of the Andrew Jackson Hotel in Nashville. The Jackson was also razed in the 1970s.

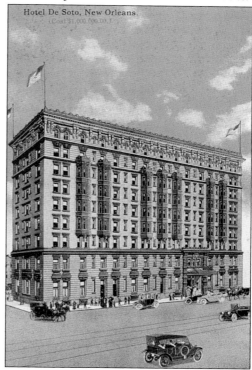

THE HOTEL DE SOTO. The exorbitantly expensive $1 million Hotel De Soto is seen here as it looked in the 1920s. As well as being famous for its Creole cuisine, the hotel contained only outside rooms, a necessity in the days before air conditioning. Rates started at $1 per day. The hotel professed to be the only absolutely fireproof hotel in New Orleans, a significant consideration for the 1920s traveler.

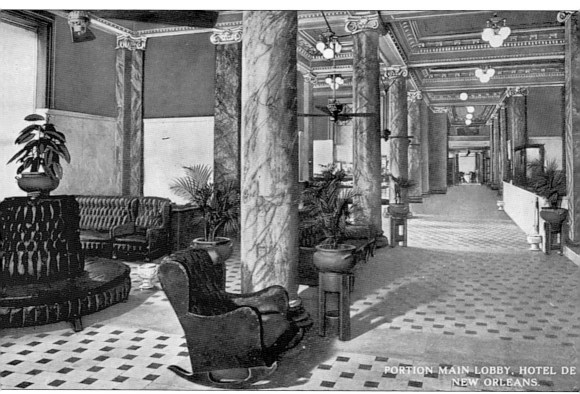

PORTION MAIN LOBBY, HOTEL DE
NEW ORLEANS.

THE MAIN LOBBY OF THE HOTEL DE SOTO. The De Soto hotel's elegant lobby, as pictured here, is characteristic of the grand hotels of the era. The ceiling fans were not merely for decorative purposes. They often provided the only air circulation available inside a building.

THE JUNG HOTEL. The Jung Hotel, located on the 1500 block of Canal Street in the heart of the Business District, was a property of Affiliated National Hotels. It originally featured 700 outside rooms, each with its own private bath. The entire first floor was air conditioned, including the coffee shop, cocktail lounge, mirror room, spacious lobby, Tulane room, meeting rooms, and barber shop.

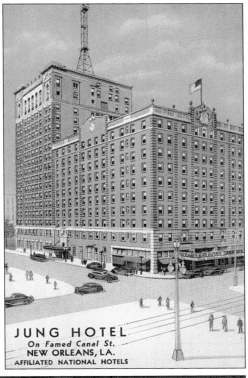

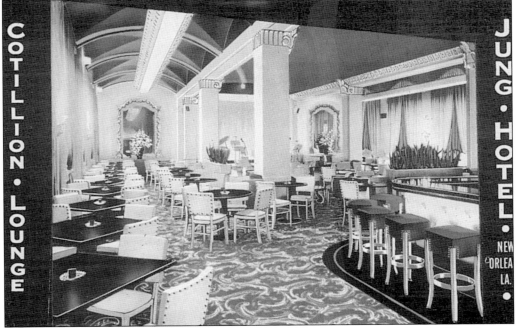

THE COTILLION LOUNGE AT THE JUNG HOTEL. By the time this photo of the Cotillion Lounge was taken, the "The South's Finest" hotel boasted 1,200 outside rooms, and was totally air-conditioned throughout.

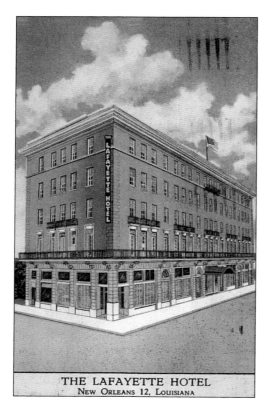

THE LAFAYETTE HOTEL
New Orleans 12, Louisiana

THE LAFAYETTE HOTEL. The Lafayette Hotel is located on Lafayette Square at 600 St. Charles Avenue, and is seen here in the late 1940s. New Orleans has always been a trade and tourist center, and the city has always offered an abundant selection of accommodations in all price ranges. The building, while lacking the size or grandeur of the former Roosevelt, for example, nevertheless possesses simple but elegant lines.

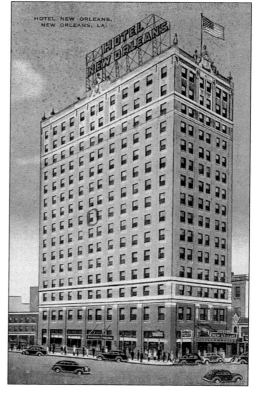

THE HOTEL NEW ORLEANS. The 15-story, 300-room, 300-bath Hotel New Orleans, pictured here in the 1940s, offered many amenities, including tub and shower combinations, circulating ice water, and ceiling fans in every room. What's more, it featured absolutely fireproof ventilated doors. This was, at one time, Canal Street's tallest building.

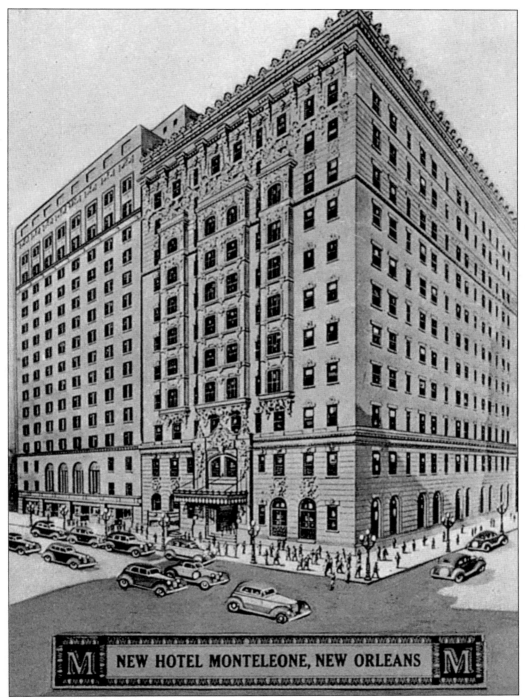

NEW HOTEL MONTELEONE, NEW ORLEANS

THE NEW HOTEL MONTELEONE. This artist's rendering shows the Monteleone Hotel, called the New Monteleone Hotel at the time, as it appeared in the late 1930s. The magnificent 800-room Monteleone is located at 214 Royal Street, on the edge of the French Quarter, and it is one of the city's most respected hotels.

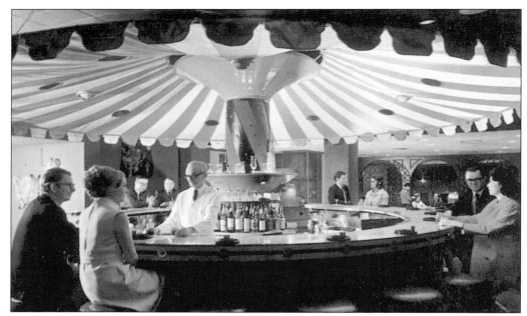

THE CAROUSEL LOUNGE IN THE HOTEL MONTELEONE. The two photographs on this page show how little the Monteleone's famous Carousel Lounge has changed over the 40-year span that is represented here. The circular bar actually revolves. The motion is so slow and subtle that the unfamiliar patron often receives a surprise. (Courtesy of Alphonse Goldsmith, New Orleans.)

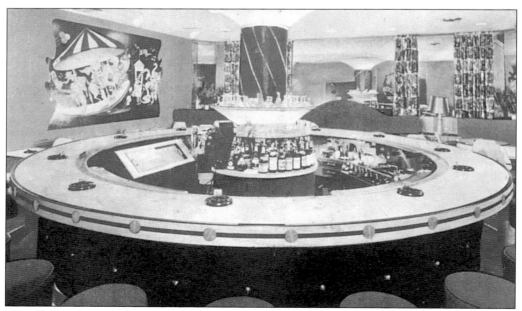

THE CAROUSEL LOUNGE. The Monteleone's Carousel Lounge featured, at the time of this photograph, the only revolving bar in New Orleans.

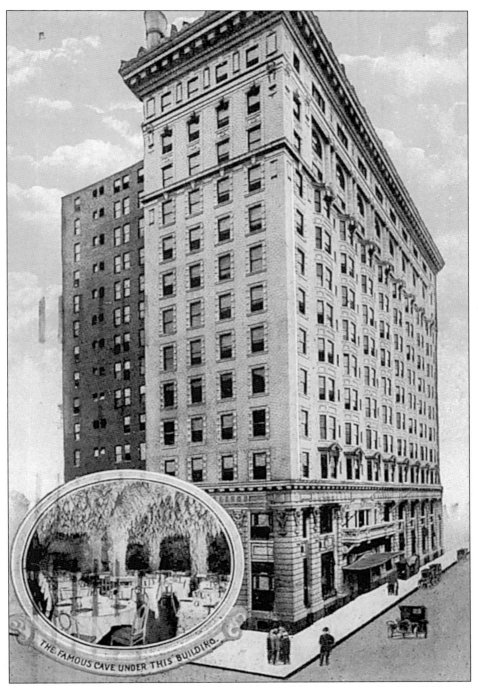

THE FAMOUS CAVE UNDER THIS BUILDING.

THE GRUNEWALD HOTEL. The newer Grunewald Hotel building, seen in this 1922 postcard, contained one of New Orleans' most unique restaurants. The Cave, as it was called, was located in the hotel's basement. Through the use of hundreds of tons of cement that were made to resemble stalagmites and stalactites, the room was transformed into a reasonable facsimile of an underground cave. Naked cement and plaster ladies added to the ambience.

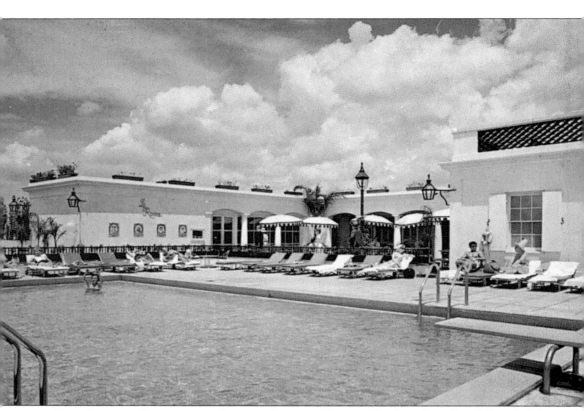

THE ROOFTOP POOL AT THE ROYAL ORLEANS HOTEL. The luxurious Omni Royal Orleans Hotel is located at 621 St. Louis, in the French Quarter. The hotel, built in 1960, is significant because it stands on the site of the former St. Louis Hotel, which was one of the two most significant hotels in New Orleans history. Rooftop swimming pools are often a necessity in downtown areas. The Monteleone, on Royal Street, also has a swimming pool on the roof.

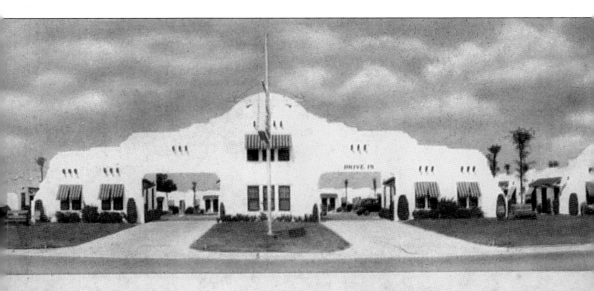

ALAMO PLAZA HOTEL COURTS

Over 600 Rooms and Apartments In 10 Courts In 6 States

WACO, TYLER, AND BEAUMONT, TEXAS

SHREVEPORT, LA. OKLA. CITY, OKLA., JACKSON, MISS. LITTLE ROCK, A
MEMPHIS, TENN. BATON ROUGE, LA. NEW ORLEANS,

THE ALAMO PLAZA HOTEL COURTS. The Alamo Plaza Hotel Courts, pictured here, obviously predate the two motel courts that follow. These were part of a chain that, at the time, included 10 courts in 6 states, with a total of 600 rooms and apartments.

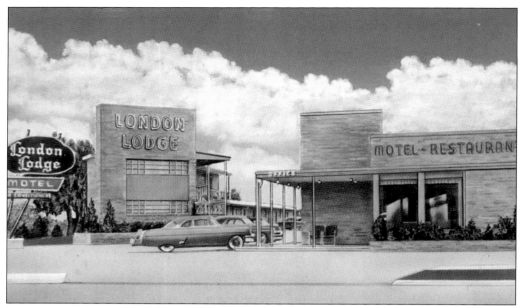

THE LONDON LODGE. Located at 9301 Airline Highway, the London Lodge Motel & Restaurant typifies the best of the motels and tourist courts that sprouted up across America during the 1950s. Gas was plentiful, and most Americans had automobiles, many for the first time. These motels were generally close to town, and featured restaurants and modern conveniences. This type of accommodation was cheaper than downtown hotels, a significant consideration for vacationing families.

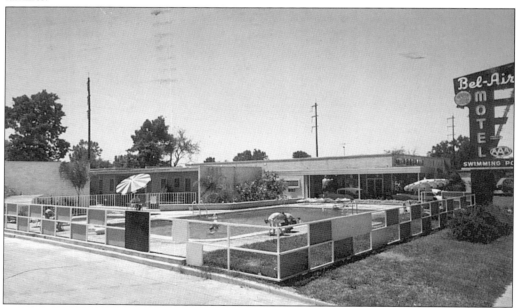

THE BEL-AIR MOTEL. The Quality Court Bel Air Motel, pictured in this photograph dating from 1959, claims to be "The South's Finest Motel." Features offered by the motel included tiled baths, tub and shower combinations, television, and swimming and wading pools. Rooms were cooled by refrigerated air, and warmed by thermostatically controlled heat.

Seven

CEMETERIES AND CHURCHES

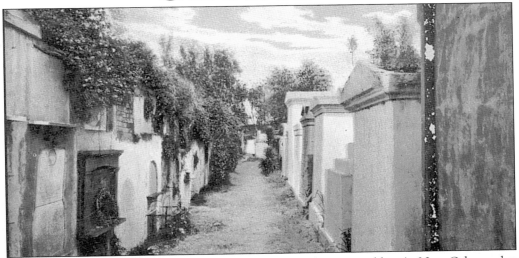

VAULTS IN THE OLD ST. LOUIS CEMETERY. Burial was always a problem in New Orleans, due mainly to the fact that the city is below sea level. The Catholic prohibition of cremation made matters worse. In the early days, coffins buried below the ground frequently floated to the surface after a heavy rain. By 1800, above-ground burial had become the standard. St. Louis Cemetery No. 1 was established in 1788.

The cemeteries of New Orleans are understandably considered to be the most unique in America. From the primitive plaster-covered brick "oven vaults" of St. Louis Cemetery No.1 to the above-ground mortuary palaces of granite and marble found in Metarie Cemetery, many would say that New Orleans is unequaled. The churches of "America's Most Interesting City" are just as magnificent in their own right. St. Roch's Chapel, the Moorish Cathedral of the Incarnation, and, of course, the French Quarter's famous St. Louis Cathedral are all culturally, historically, and architecturally important parts of the New Orleans mystique.

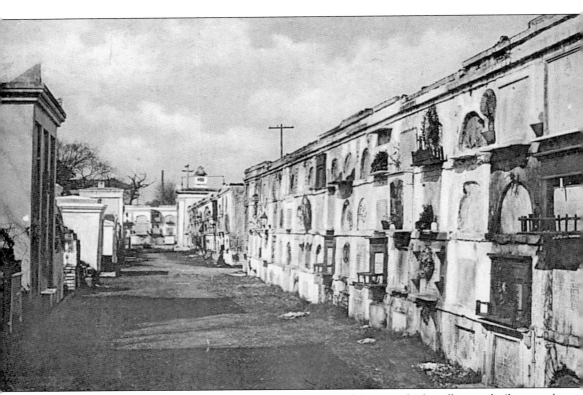

VAULTS IN THE ST. LOUIS CEMETERY. In the early days of the city, thick walls were built around cemeteries for the purpose of confining diseases. Cemetery vaults evolved from these walls. These "oven" vaults, as they are called, provided an affordable alternative to the extravagant family crypts seen in early New Orleans cemeteries. Traditionally, the vaults were stacked four stories high, that is, high enough to accommodate four burial vaults. The coffins were simply inserted into the walled chambers, then sealed at the open end with bricks, marble, or wood. An inscription identifying the occupant was affixed to the sealed end.

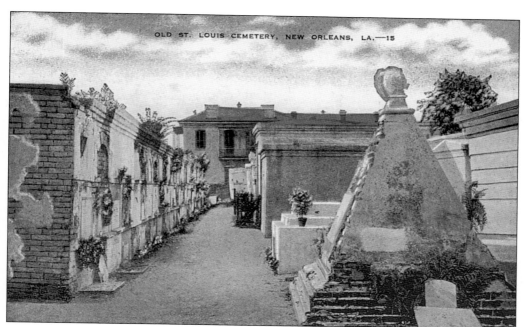

THE OLD ST. LOUIS CEMETERY. The early tombs were constructed in much the same manner as the houses and buildings of the time, with cement or plaster over brick, and then painted white.

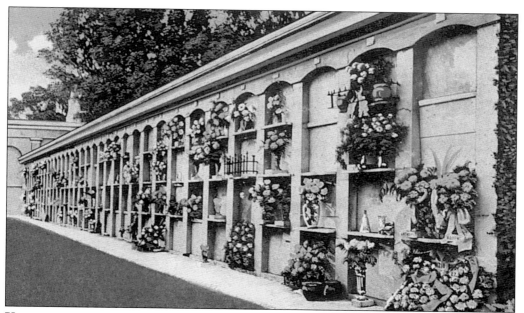

VAULTS OF THE OLD ST. LOUIS CEMETERY, ALL SAINTS DAY. It was customary for family members to decorate the graves and vaults of ancestors and loved ones on November 1, which is known as the Catholic "All Saints Day." Many photographs and postcards have been made on this most colorful day in New Orleans cemeteries. The tradition continues to this day, and is viewed as a time to pay respects to ancestors, as well as providing an opportunity to clean up and maintain the cemeteries.

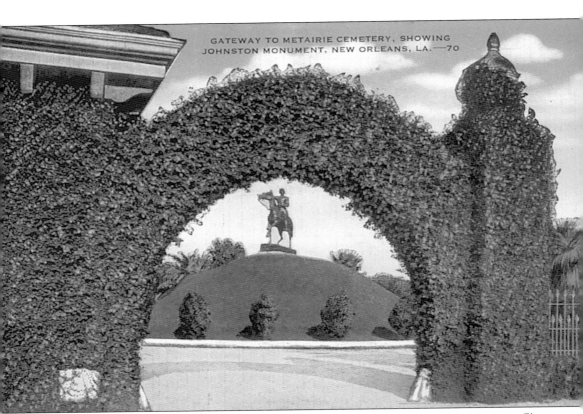

THE GATEWAY TO METARIE CEMETERY, SHOWING THE JOHNSTON MONUMENT. Since cemeteries were always placed on the outskirts of town, at the far edge of a city, it is an easy way to trace the development and growth of a city. This is certainly the case in New Orleans. The arched ivy-covered gateway to Metarie Cemetery leads to the statue of Confederate officer Albert Sidney Johnston. This magnificent monument of Johnston and his horse is situated atop the tomb containing soldiers of the Army of Tennessee. General Beauregard is also buried here. (Courtesy of New Orleans News Company.)

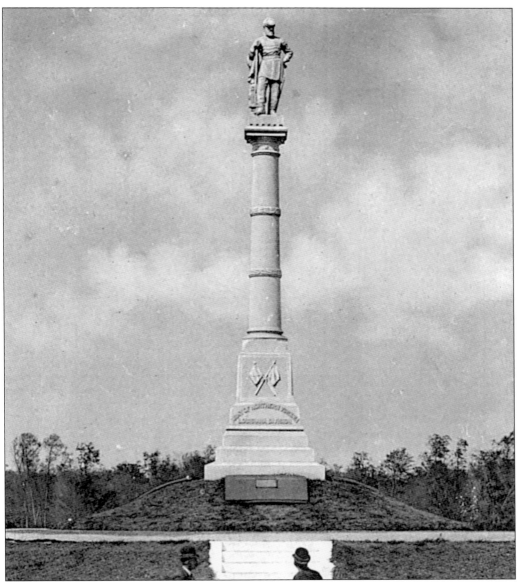

THE STONEWALL JACKSON MONUMENT, METARIE CEMETERY. New Orleans, quite possibly, has more monuments than any other city in America. This is in part due to the large number of significant people who have in some way been associated with the city during its long and colorful history. Other monuments, memorials, and parks seemingly have no particular relevance to New Orleans, other than that the honorees were deemed worthy of honor. There are monuments dedicated to, among others, Louis Armstrong, Henry Clay, Irish yellow fever victims, famous battles, saints, civil-rights leader Martin Luther King, Jefferson Davis, Benjamin Franklin, Latin-American heroes, past mayors, historians, Freemasons, philanthropists, and a former Supreme Court Justice. According to legend, this former racetrack was turned into a cemetery, in 1870, by a black-balled member of the Old Metarie Racing Club. The cemetery, one of more than 40 in the New Orleans area, is characterized by its ornate above-ground tombs and crypts.

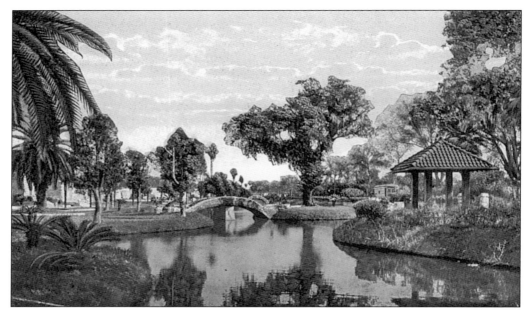

THE LAKE IN METARIE CEMETERY. This lake in Metarie Cemetery shows the attention to detail involved in the area's planning. Live oaks, palms, walkways, and exquisitely manicured gardens all contribute to making this the most beautiful cemetery in America. There are more than 4,000 individual free-standing tombs in this 150-acre cemetery.

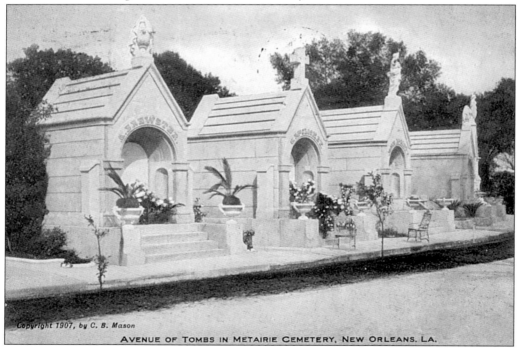

AVENUE OF TOMBS IN METAIRIE CEMETERY, NEW ORLEANS, LA.

THE AVENUE OF TOMBS IN METARIE CEMETERY. This 1907 photograph shows the Metarie Cemetery nearly 40 years after it opened. Four near–identical tombs are shown here, most likely belonging to the same family.

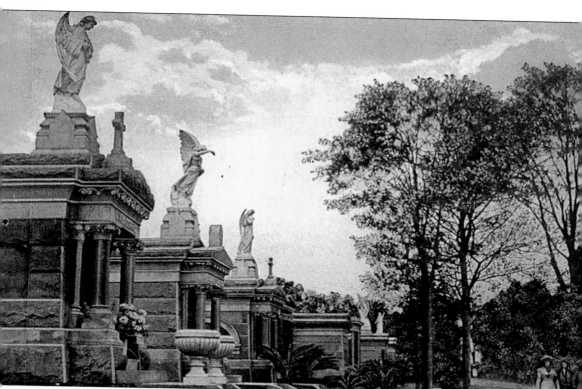

METARIE CEMETERY SEVERAL SHOWING FINE TOMBS. Metarie Cemetery is one of the most elaborate cemeteries in America. Here, during the period between 1870 and 1930, American mortuary art and architecture reached their highest point. Massive and magnificent tombs of cut, carved, and polished marble and granite were constructed like miniature cathedrals, and fitted with bronze doors, stained-glass windows, and cast- and wrought-iron gates and rails.

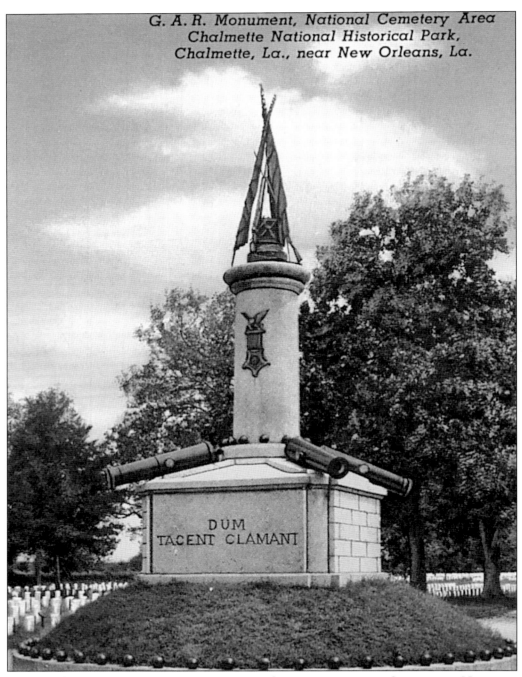

DUM
TACENT CLAMANT

THE GAR MONUMENT IN THE NATIONAL CEMETERY AT THE CHALMETTE NATIONAL HISTORICAL PARK. The National Cemetery was established in 1864, and is located outside New Orleans within the Chalmette National Historical Park. It contains the remains of more than 15,000 veterans. A plaque in Latin translates "Though Silent, Still Let Them Be Heard." The park is operated by the National Park Service, which is a part of the U.S. Department of the Interior. (Courtesy of A. Hirschwitz, New Orleans.)

THE CHURCH OF THE IMMACULATE CONCEPTION. Located on Baronne and Canal, this Moorish–style building is popularly known as the Jesuit Church. The first church on this site was erected in 1848, the second in 1857, and the third is pictured here. (Courtesy of New Orleans News Company.)

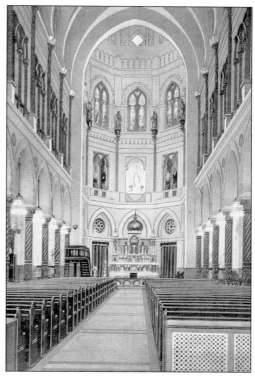

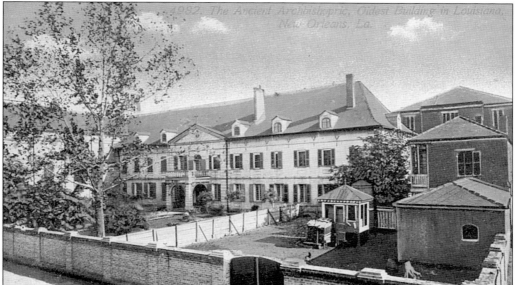

THE ANCIENT ARCHBISHOPRIC, THE OLDEST BUILDING IN LOUISIANA. This building, known as the Archbishopric, is located at 1102 Chartres Street. It was erected in 1752 for the Ursuline Nuns, and it replaced the earlier 1727 structure. In 1824 it was presented to the reigning archbishop of New Orleans, to be used as the residence for the archbishops of the diocese, and it served in that capacity until 1899. It was restored in 1970 by the archdiocese, and renamed the Archbishop Antoine Blanc Memorial.

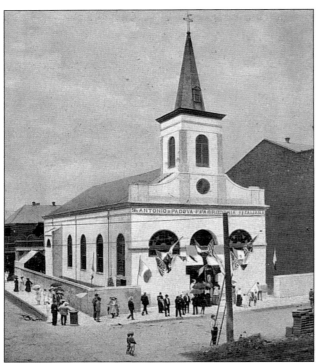

THE ST. ANTONIO LATIN CHURCH. Churches have always played a significant part in New Orleans history, especially Catholic churches. The St. Antonio Latin Church was one of several that served New Orleans' Spanish-speaking population.

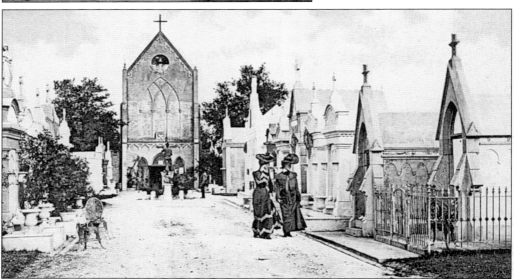

ST. ROCH'S CEMETERY AND CHAPEL. St. Roch's Chapel was built in 1871 by Father Thevis, who promised St. Roch that he would build a church in his honor if he would help the congregation through the yellow fever epidemic of 1866–67. None of his congregation died, and the church was built. The chapel only holds 24 people, and the walls on either side consist of tombs. The church houses a large and freaky collection of crutches, braces, artificial limbs, and other items left by those who claim to have been cured. Churches and cemeteries have always played an important part in the lives of New Orleans' residents. The clothing worn by these women indicates that this photograph was taken before 1910.

Eight

PARKS AND RECREATION

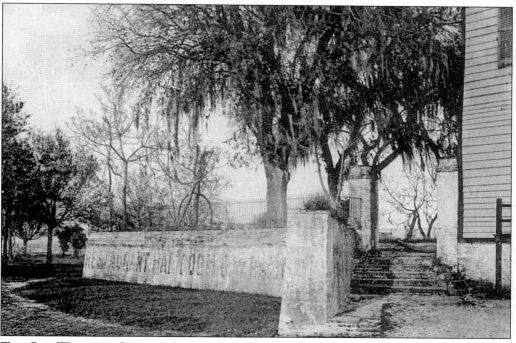

THE OLD WALL AND STEPS OF SPANISH FORT. In the 1700s, the French rulers of New Orleans, at the time of Baron de Carondelet, constructed a fort on Lake Ponchartrain that was expanded by the Spanish in 1779. It was allowed to decay, was torn down, and the Pontchartrain Hotel was erected on the site in 1823. In 1883, the land was put to use as a public amusement park. It was abandoned, burned down, and rebuilt before the amusement park finally moved to a new location. A wall and a few ruins remained, which are still called "Spanish Fort."

New Orleans, like Savannah for instance, has many public parks within the city limits. The parks in New Orleans, however, are much larger. They vary in size, from the 1,500-acre City Park to the 245-acre Audubon Park to smaller, but equally refreshing, public parks such as Lafayette Square, Lee Circle, the area surrounding the Margaret Statue, and, of course, Jackson Square. Parks throughout the city provide a variety of attractions, from a quiet park bench to tennis courts, elaborate fountains, and swimming pools.

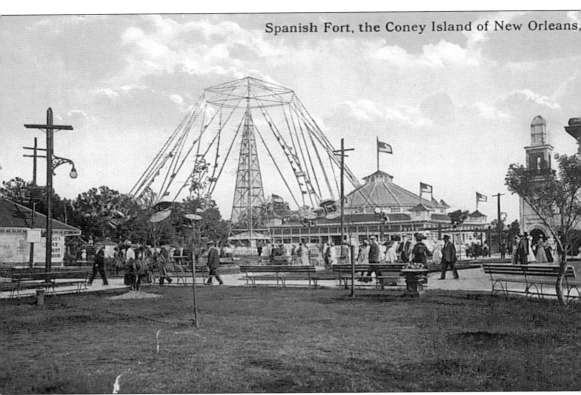

SPANISH FORT, THE CONEY ISLAND OF NEW ORLEANS. The amusement park at Spanish Fort is shown at its zenith, between 1900 and 1910. During this time the ruins of the fort and the dismantled guns could still be seen.

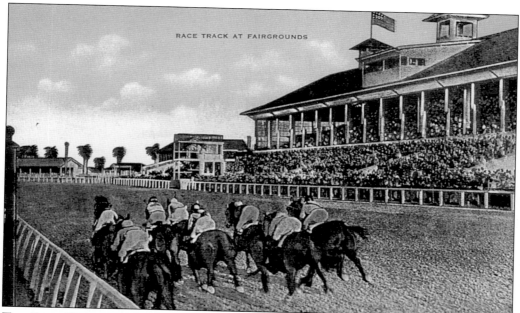

RACE TRACK AT FAIRGROUNDS

THE RACE TRACK AT THE FAIRGROUNDS. Horse racing has always been a popular sport in the Crescent City. Early horse tracks include the former Old Metarie Racing Club's track. The Race Track at the Fairgrounds, pictured here, is one of the oldest horse tracks in the nation. Racing season traditionally opens on Thanksgiving Day, and runs through the middle of April. The historic century-old building in this view, however, burned in December 1993.

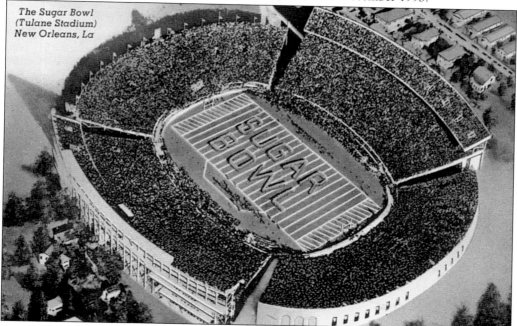

The Sugar Bowl
(Tulane Stadium)
New Orleans, La

SUGAR BOWL. The Sugar Bowl, a game traditionally held on New Year's Day, is a New Orleans tradition. For years it was played at Tulane's football stadium. Today, the New Orleans Superdome hosts the Sugar Bowl, as well as the Tulane football team's home games.

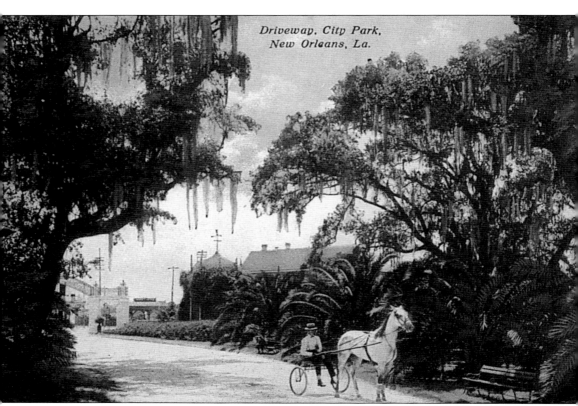

Driveway, City Park,
New Orleans, La.

THE DRIVEWAY TO CITY PARK. This entrance to City Park shows the heavy concentration of Spanish moss that is so prevalent in Louisiana. In fact, both the live oaks and palms of Louisiana are without equal. The gate at the left side of this photograph was donated to the city by Italian philanthropist Ettore Pizzati.

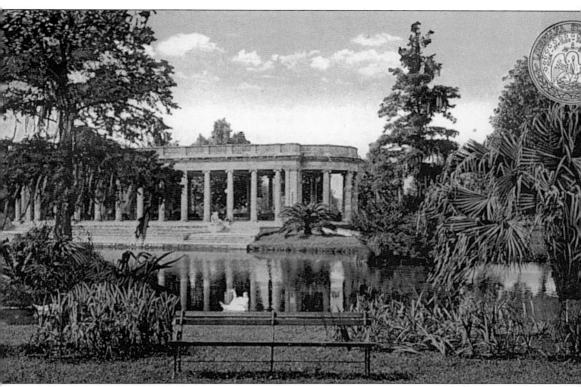

A November Scene in City Park. The semi-tropical climate that has made New Orleans famous as a winter resort is clearly indicated by the richness of the foliage in this beautiful winter park scene. The building in the distance was built between 1906 and 1907 and is known as "The Peristyle." Its lion–flanked steps lead to the water's edge.

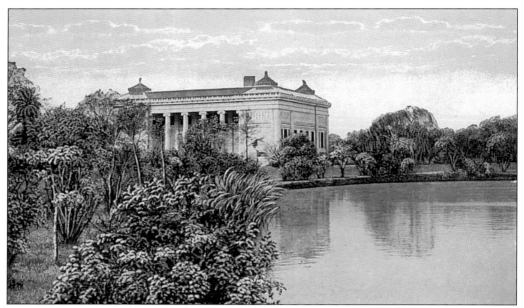

THE DELGADO MUSEUM OF ART, CITY PARK. The Delgado Museum of Art is pictured here, across the lake, in City Park. It was constructed in 1911 with funds donated by Isaac Delgado. The museum was expanded in 1971, mainly with city funds, and the name was changed to the New Orleans Museum of Art.

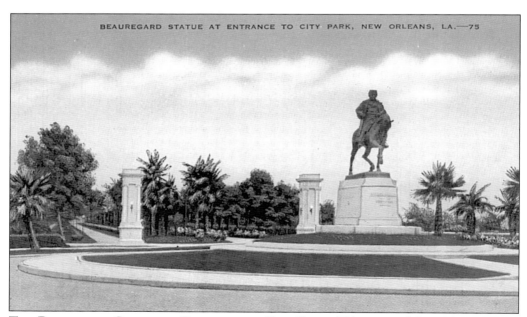

THE BEAUREGARD STATUE AT ENTRANCE TO CITY PARK. This statue of General Beauregard was erected by the Beauregard Memorial Association at the entrance to City Park, at the end of Esplanade. General Beauregard was not only a great West Point-trained Confederate general, he was also a famous architectural engineer who was associated with many of the Crescent City's most notable post-war buildings. (Courtesy of New Orleans News Company.)

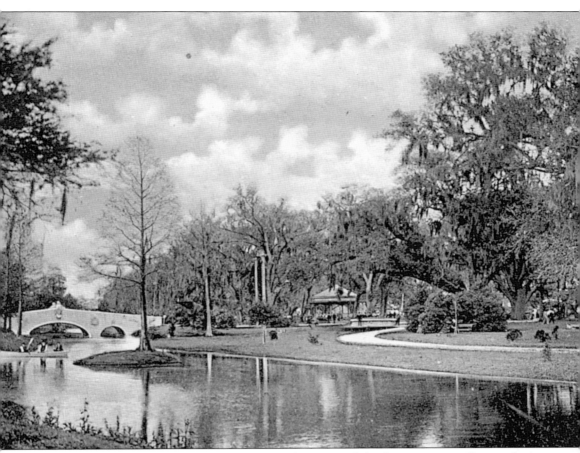

City Park. New Orleans' 1,500-acre City Park is one of the largest metropolitan parks in America. Originally known as Allard Plantation, it was purchased at auction by John McDonogh and willed to the city after his death.

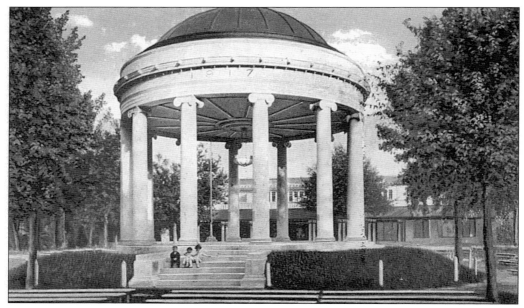

THE BANDSTAND AND CASINO, CITY PARK. The magnificent bandstand at City Park (1912) has been the scene of many top concerts.

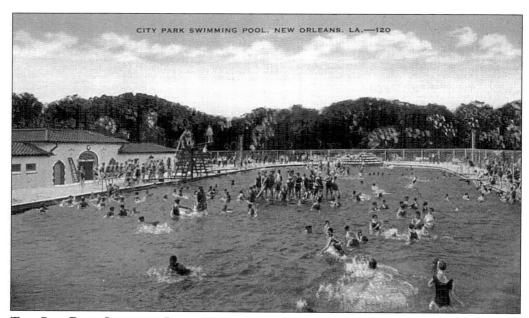

THE CITY PARK SWIMMING POOL. Swimming pools have always been popular in New Orleans. This swimming pool, one of many in the city, was built at City Park in 1925 at a cost of $100,000, and was billed as "a model of health and safety."

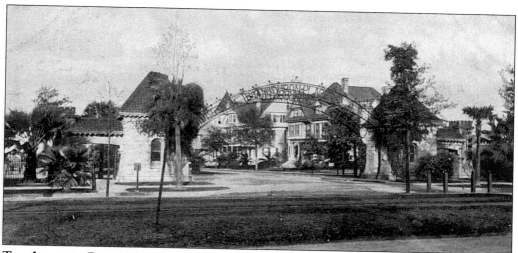

THE AUDUBON PLACE. This photograph, *c.* 1930, shows the entrance to Audubon Park. The park is situated on the site of a former plantation that was owned by Etiene Bore (1741–1820), who is known as the "Father of Granulated Sugar."

THE ENTRANCE FROM ST. CHARLES AVENUE TO AUDUBON PARK. Loyola University, visible in the background of this image, was built on land that had housed the World's Industrial and Cotton Centennial Exposition. Audubon Park was created between 1884 and 1885 after the close of the cotton exposition, and is named in honor of John James Audubon. Audubon was born in Santo Domingo in 1785, and moved to France before making his way to America. Here he met with repeated failure and poverty, but he found his way to Louisiana, where he sketched the majority of subjects for his classic *Birds of America.* Unable to find a publisher in America, he went to London and found a publisher there. His success was immediate and widespread, in that most of Europe had never seen many of the birds his work presented. He returned to America where he also became highly successful. Audubon always had an ongoing love for Louisiana and New Orleans.

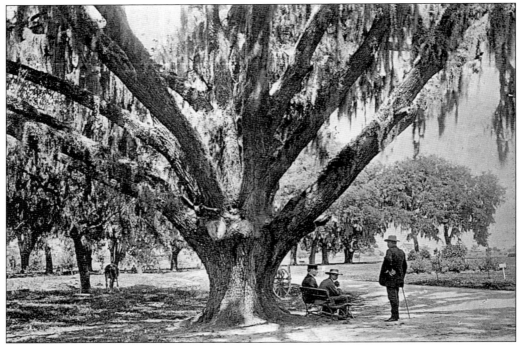

LIVE OAK AVENUE IN AUDUBON PARK. Live oaks and palm trees are the favorite trees of New Orleans. The beautiful live oaks, like the one pictured here, live for hundreds of years and attain a great size. The branches spread widely, and are usually draped with Spanish moss.

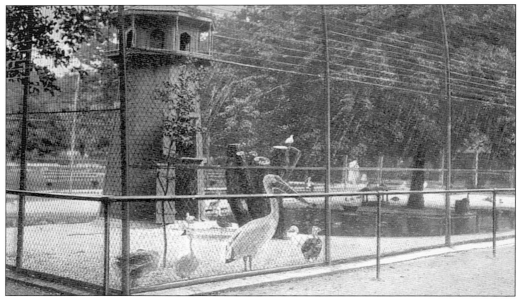

A BIRD CAGE AT AUDUBON PARK. Audubon Park has an elaborate and wonderful zoo, which was originally established in 1938. Today, the zoo houses a wide variety of displays, including natural swamp exhibits, primates, and other animals, of which, in total, there are more than 1,000. In addition to the animals, there are beautiful flowers and vegetation.

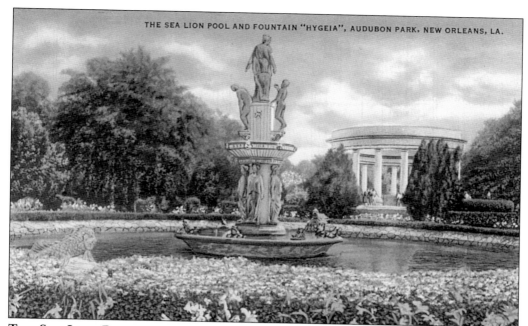

THE SEA LION POOL AND FOUNTAIN "HYGEA" AT AUDUBON PARK. The sea lion pool and fountain were given to the city's Audubon Park by Sigmund Odenheimer. Today, the zoo, park, aquarium, and other properties are operated under the auspices of the non-profit Audubon Institute.

THE WADING POOL AT AUDUBON PARK. The aquarium and zoo can be seen in the background of this picture. The aquarium, formerly located at Audubon Park, as seen here, has since been established in an exotic new building downtown in 1990, and renamed the Aquarium of the Americas. A shuttle boat named the *John James Audubon* makes runs between the park and the aquarium.

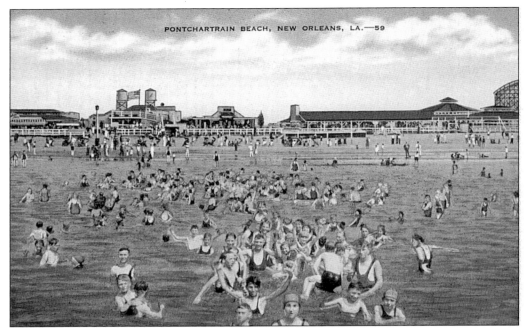

PONTCHARTRAIN BEACH. At the north end of New Orleans' Lake Pontchartrain is this salt–water lake, which is a favorite swimming place for local residents.

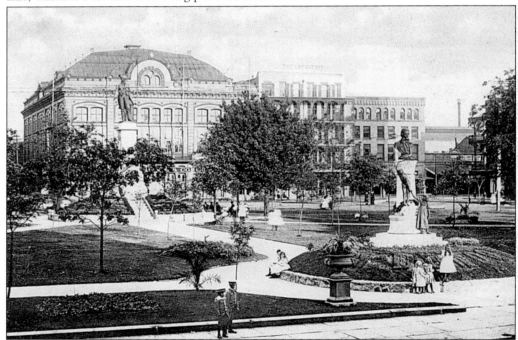

LAFAYETTE SQUARE. Lafayette Square was named in honor of General Lafayette in 1825, but it existed as a park as early as the late 1780s. The beautiful area, located across from old city hall, contains the John McDonogh Monument (see following page) as well as a statue of Benjamin Franklin and another of statesman Henry Clay.

LA PLACE DE VILLE, LAFAYETTE SQUARE. Lafayette Square is located in the financial center of New Orleans. The tall building in the left center of the photograph is the Hibernia Bank building, the tallest building in the city for many years.

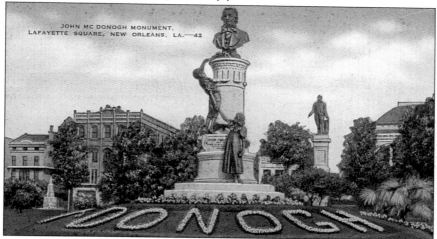

THE JOHN MCDONOGH MONUMENT IN LAFAYETTE SQUARE. The story of Maryland native John McDonough and his impact on the city is quite remarkable. McDonough moved to New Orleans shortly before New Orleans became an American city and became wealthy in his new hometown. He lived in a large plantation on the west bank of the Mississippi River, and would row a boat across the river rather than spend the money for the ferry. He was disliked by New Orleanians because he was reclusive and pecuniary. Upon his death in 1850, however, it was discovered that he had left the city $2 million, which was an incredible amount of money for the time. It was this endowment that basically established the New Orleans public school system. The city was embarrassed at the treatment he had received in life, and so decided to honor him with this 1898 statue by Attilio Piccirilli. According to the inscription on the back of an old postcard, "John McDonough, who became a recluse after being disappointed in love in New Orleans, left half his large fortune to the cause of education in New Orleans. 32 public schools have been built with money he left. His monument in Lafayette Square was built with the dimes of greatful school children, and every year in May the statue is covered with flowers from the children." This close up of the McDonough Monument shows the bust of the patron atop a simple, but elegant, marble tower. Two children, a boy and a girl, join hands in reaching toward him.

113

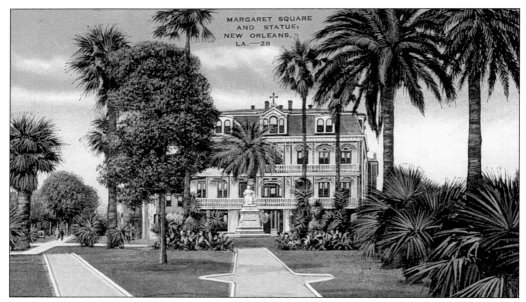

MARGARET SQUARE AND STATUE. Margaret Gaffney Haughery (1813–1882) devoted herself to good works, following the deaths of her husband and child. Most of the money she made from a bakery and dairy that she owned was given to the needy and for the care of orphans. Upon her death, St. Theresa's Orphanage, and St. Vincent's Infant Asylum were established. The statue was erected in 1884 and is located at Camp and Prytania Streets. (Courtesy of New Orleans News Company.)

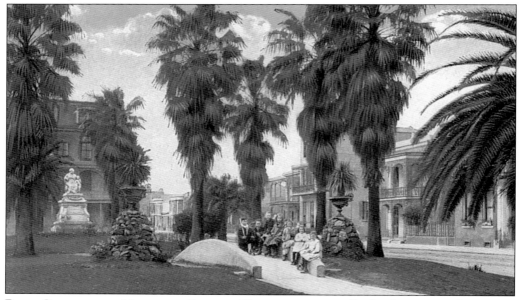

PALM GARDEN AND MARGARET STATUE. The statue, supposedly the first statue of a woman erected in the United States, shows the seated woman wrapped in a shawl, looking down at a child standing to her left. "They are all orphans," she had said. Simply marked with the inscription "Margaret," the statue is located in a triangular park at the intersection of Camp, Prytania, and Clio Streets.

Nine

HEALTH AND EDUCATION

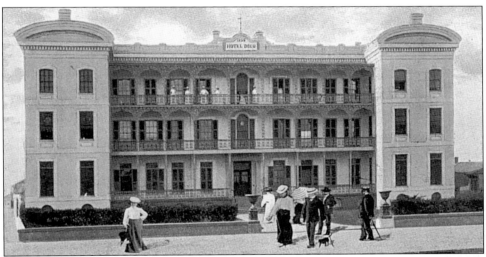

HOTEL DIEU. The three-story Hotel Dieu, literally the "House of God," was built in 1858 as a private charity hospital that operated under the auspices of the Sisters of Charity. It was located on Tulane Avenue, and occupied the square between Bertrand and Johnson Streets. In 1884, the first story was found to be too low, and the large brick structure was physically raised.

The concerns of health and education have always been important to New Orleanians. A number of hospitals, both public and private, have been part of the civic landscape since the earliest days of the city. Religious institutions, the Catholic Church in particular, have made many significant contributions to hospitals and medical facilities, as well as to education. There have also been many gifts of funds, lands, and other resources provided by private individuals, both living and dead (through wills and estates). As a result of these types of contributions, as well as those from the city itself, New Orleans possesses many wonderful hospitals, universities, and religious-based learning institutions.

NEW CHARITY HOSPITAL. The gigantic Charity Hospital (referred to as New Charity Hospital here) at 1532 Tulane was built in 1939 as a state-operated charity hospital. The massive 20-story building also serves as a training facility for the Louisiana State University Medical School and Tulane University. The original Charity Hospital opened in 1834 on the same site, and was, at the time, the largest building in New Orleans. It was razed in 1938 to make way for the hospital pictured here.

LOYOLA UNIVERSITY. Shown here, from left to right are, Loyola University's Church of the Most Holy Name; Marquette Hall; and Thomas Hall. The school that is located on St. Charles Avenue became Loyola University in 1912, but was originally started as Loyola Academy in 1904. Interestingly, the land that houses the Loyola and Tulane Universities, as well as Audubon Park, was the site of an extravagant but financially unsuccessful fair in 1884 known as the World's Industrial and Cotton Centennial.

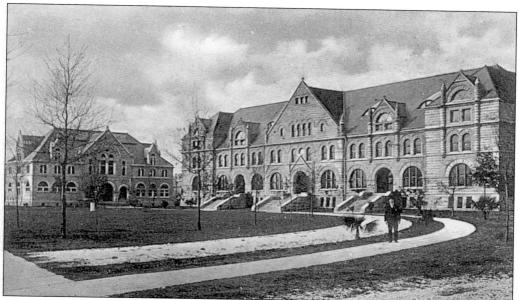

TULANE UNIVERSITY. Tulane University was established in 1834 as the Medical College of Louisiana before later becoming the University of Louisiana. Following large gifts from Paul Tulane, the institution became the Tulane University of Louisiana. In 1884, the state bowed out and Tulane became a private university. Gibson Hall, pictured here, was built between 1893 and 1894.

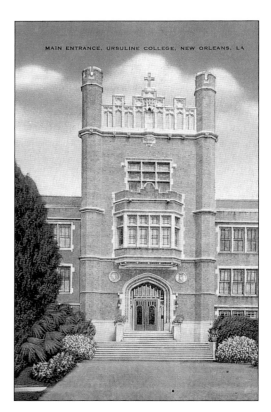

THE MAIN ENTRANCE OF URSULINE COLLEGE. The main building of Ursuline College, as pictured here, is one of the most imposing and magnificent buildings in the Garden District. (Courtesy of New Orleans News Company.)

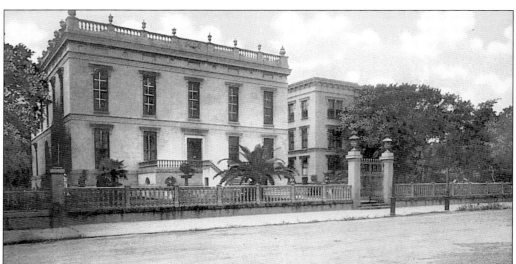

SOPHIE NEWCOMB COLLEGE. This college was established for young women in 1887 by Mrs. Joseph Newcomb in memory of her daughter, Harriott Sophie Newcomb. The Robb House, pictured here, was its second home. Eventually, the college moved to larger facilities. During its heyday, the Newcomb College became nationally known for its pottery school. Pieces of pottery that were produced here are sought by collectors, both nationally and worldwide. Today, Newcomb College is a part of the Tulane University complex.

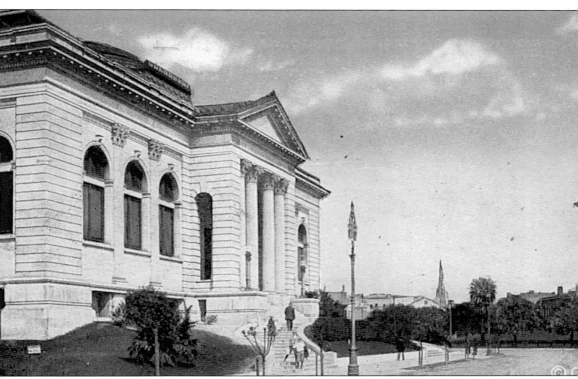

THE NEW ORLEANS PUBLIC LIBRARY AND LEE MONUMENT. The New Orleans Public Library, as seen in this photograph dating from 1919, was donated by Andrew Carnegie and contained the Fisk and Lyceum Libraries. It was eventually demolished, and the new main public library was opened on Loyola in the fall of 1958.

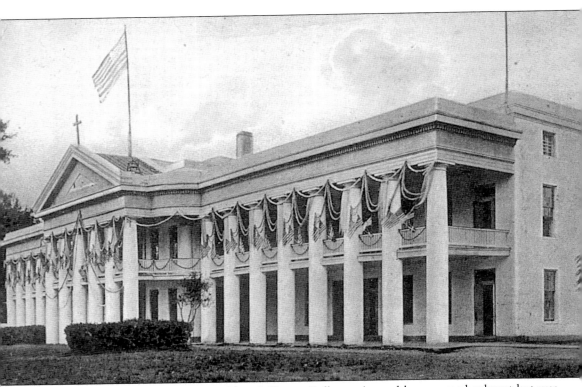

JEFFERSON COLLEGE. The magnificent Jefferson College, pictured here, went bankrupt but was rescued by Valcour Aimee and given to the Marist Fathers, a Catholic franchise. It was closed in 1927, acquired by the Jesuits, and is now used as a retreat.

Ten

BUILDINGS

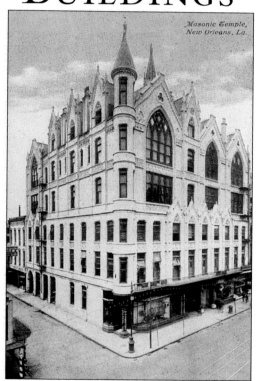

Masonic Temple,
New Orleans, La.

THE MASONIC TEMPLE. The gigantic, Gothic-style Masonic Temple, as seen here, was built at the corner of St. Charles and Perdido Streets in 1891. It served as the headquarters of the Masonic Fraternity of Louisiana until 1926, when it was replaced by a newer structure.

New Orleans has benefited immensely from the influences of many cultures, from the Creole, French, and Spanish to the classic Greek Revival of the plantation-era South. Greek Revival and classical architecture continued after the Civil War, but new styles began to make their appearances. Richardsonian Romanesque, art deco, and modern styles all played a part in the rich architectural pageantry of the Crescent City.

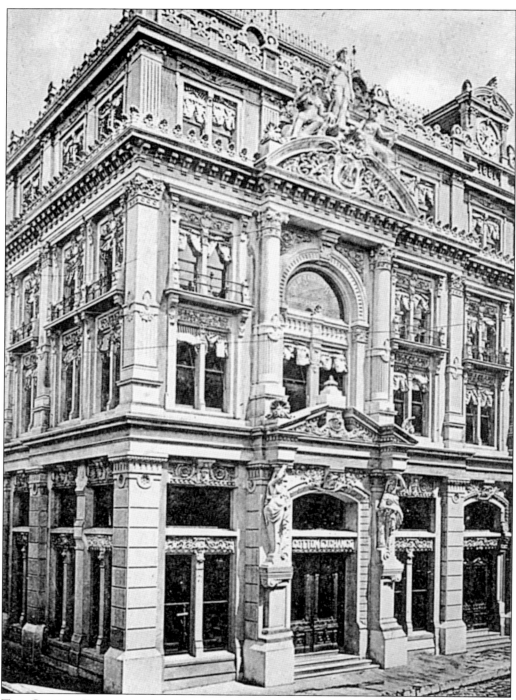

THE COTTON EXCHANGE. The Cotton Exchange was built at a cost of nearly $400,000 in the late 1800s. It was an elaborately detailed building, and was the first commercial building in New Orleans to have a cellar. Despite its considerable expense and grandeur, it did not last long, and was torn down by the end of the century.

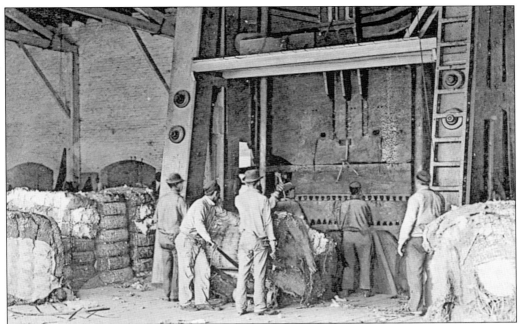

A Cotton Compress. Before cotton can be shipped, it must be compressed into bales and bound. This photograph, dating from the turn of the century, shows workers at one of the giant compressing machines. Cotton has long been one of the main agricultural exports of the South. Cotton would be shipped to New Orleans, via the Mississippi River, and then by ocean to the rest of the world.

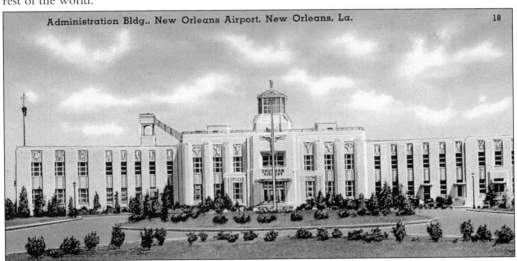

THE ADMINISTRATION BUILDING AT THE AIRPORT. The New Orleans Airport administration building, pictured here, was built in 1934 on a man-made peninsula approximately 6 miles northeast of the city. The New Orleans Airport, originally called the Old Shushan Airport, became one of America's finest combined land and seaplane bases. It was erected at a cost of over $4.5 million. This view of the beautiful old administration building shows how its flight control tower blended within the structure's elegant art deco lines. (Courtesy of Jack Pulitzer & Bro., New Orleans.)

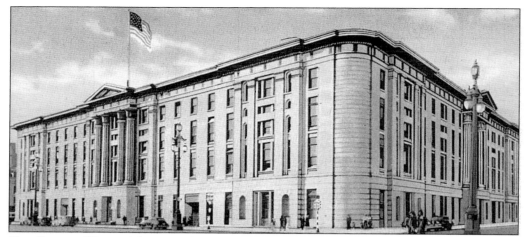

THE CUSTOM HOUSE. The United States Custom House, at 423 Canal Street, is one of the oldest government-owned buildings in the South, and is it also a Louisiana landmark. The massive and solid granite structure was the fourth custom house to occupy this spot. It was started in 1848, prior to the Civil War, with future General Beauregard involved in its construction. Due to the Civil War, construction was delayed, during which time the building served as Union General Butler's headquarters. After the Civil War, during Reconstruction, this was the stronghold of corrupt federal government forces that, with carpetbagging cronies, sought to subjugate and exact revenge upon the formerly Confederate New Orleans. It was here, in front of this building that the "Battle of Liberty Place" was fought. The building is an architectural masterpiece by any standards, but its interior "Marble Hall" is its most significant feature. This incredibly beautiful central hallway consists of a 125-by-95-foot black-and-white marble floor, surrounded by a total of 14 marble columns with Corinthian Capitols. The walls are adorned with relief carvings of Andrew Jackson, Bienville, and the state emblem, a pelican. The custom house is open to the public during regular weekday hours. (Courtesy of A. Hirschwitz.)

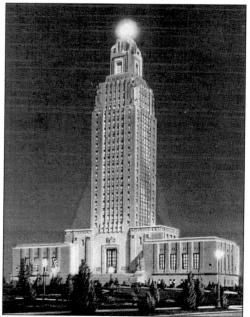

THE STATE CAPITOL AT NIGHT. The Louisiana State Capitol Building, although located upriver from New Orleans in Baton Rouge, is very much a part of New Orleans life. The 34-story, 230-foot-tall building has 249,000 square feet of usable floor space. Over 30 different types of marble were used in the $5 million construction of the tallest state capitol building in America. It remains a living legacy to Huey P. Long, alternatively known as "The Kingfish," one of America's legendary political bosses.

The Hibernia Bank. The 23-story Hibernia Bank building at Carondelet and Gravie, 2 blocks off Canal Street, was the city's first skyscraper. It remained the tallest building in New Orleans until 1962. Atop the building is a round belvedere that, during the bank's long history, has served a variety of functions. Today, it is illuminated with different colored lights for different events throughout the year, and is fairly visible throughout most of the central Business District.

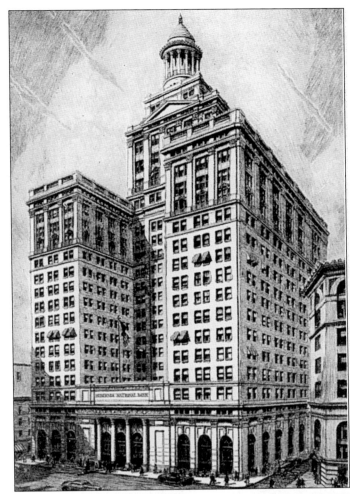

The Main Lobby of the Hibernia Bank. The main banking room of the Hibernia Bank & Trust Company is finished in Tavernelle marble and American walnut, and covers an area of one half acre. The 42 cages and 3 entrances are of appropriately decorated bronze. The subdued gold of the ceiling adds the necessary warmth to the color scheme.

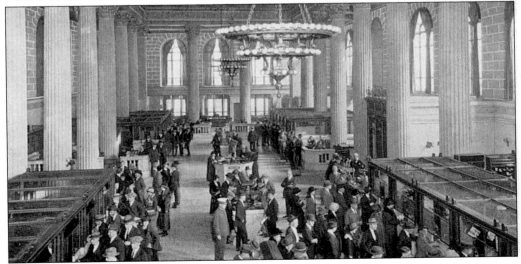

American Sugar Refining Co., New Orleans, La.

THE AMERICAN SUGAR REFINING COMPANY. The American Sugar Refining Company, located in Chalmette, was built on the site of Three Oaks Plantation, which was still standing when this picture was made. The growing season for sugar cane is around 12 months, but the Louisiana climate, unlike that of the West Indies, only permitted growth for 9 months. The problem of extracting significant sugar from an immature crop was solved by Jean Eteinne De Bore (1741–1820), who is known as the "Father of Granulated Sugar." This is a title of great significance, since sugar was the major crop of the plantations closest to New Orleans. Bore was also the first mayor of New Orleans.

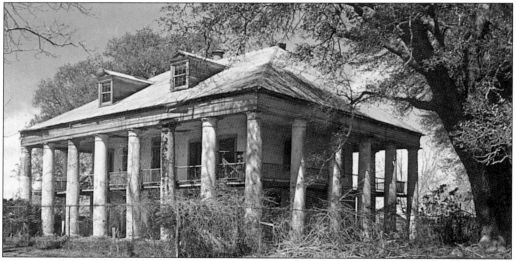

HERMITAGE PLANTATION. Hermitage Plantation is seen here prior to its restoration. It was built between 1812 and 1814 by Michael Doradou Bringier, who was an aide to and great admirer of Andrew Jackson. Bringier entertained Jackson here after the Battle of New Orleans, and he named the house in honor of Jackson's Tennessee home, the Hermitage. While this house was fully restored to its original glory, many more that could have been saved were considered of little consequence, and were consequently abandoned, razed, or burned down. (Courtesy of Grant L. Robertson, New Orleans.)

BIBLIOGRAPHY

Alciatore, Roy L. *Souvenir Du Restaurant Antoine*. New Orleans, LA: n.p., 1940.

Asbury, Herbert. *The French Quarter*. New York City, NY: Alfred A. Knoph, Inc., 1936.

Cable, Mary. *Lost New Orleans*. N.p.: American Legacy Press, 1980.

Chopin, Kate. *The Awakening*. CommonPlace Publishing, 1899. New YorkCity, NY: Simon & Schuster Editions, 1996.

Clisby Arthur, Stanley. *Old New Orleans*. New Orleans, LA: Harmanson, 1955.

Delehanty, Randolph. *Ultimate Guide to New Orleans*. San Francisco, CA: Chronicle Books, 1998.

Deutsch, Herman. *Brennan's New Orleans Cookbook*. New Orleans, LA: Robert L. Crager & Co., 1961.

Ebeyer, Pierre Paul. *Paramours of the Creoles*. New Orleans, LA: Windmill Publishers, 1944.

Fodor's 89 New Orleans. New York City, NY: Fodor's Travel Publications, Inc.,1988.

Forbes, Suzi. New Orleans, *A Photographic Journey*. New York Cuty, NY: Crescent Books, 1991.

Garvey, and Widmer. *Beautiful Crescent-A History of New Orleans*. New Orleans, LA: Garmer Press, 1982.

Gray Taylor, Joe. *Louisiana, A Bicentennial History*. New York City, NY: W.W. Norton & Co. Inc.,1976.

Kane, Harnett. *Queen New Orleans*. New York City, NY: William Morrow & Co., 1949.

Kinney, Robert. *The Bachelor in New Orleans*. New Orleans, LA: Bob Riley Studios, Inc., 1942.

Laughlin, Clarence John. *Ghosts Along The Mississippi*. New York City, NY: Bonanza Books, 1948.

Lynn, Stuart M. *New Orleans*. New York City, NY: American Legacy Press, 1949.

Lyons, Nan. *New Orleans Agenda*. Redondo Beach, CA: Fielding Worldwide, Inc., 1977.

Malone, Lee and Paul Malone. *The Majesty of New Orleans*. Gretna, LA: Pelican Publishing, 1991.

Parkinson Keyes, Francis. *All This is Louisiana*. New York City, NY: Harper & Brothers Publishers, 1950.

Pitkin Schertz, Helen. "Legends of Louisiana." *New Orleans Journal*, 1922.

Rand, Clayton. *Stars in Their Eyes*. Gulfport, LA: Dixie Press, 1953.

Samuel, Martha and Ray Samuel. *The Great Days of the Garden District, and the Old City of Lafayette*. New Orleans, LA: Parents League of the Louise McGehee School, 1961.

Saxon, Lyle. *Fabulous New Orleans*. New York City, NY: The Century Company, 1928.

Searight, Sarah. *New Orleans*. New York City, NY: Stein and Day, 1973.

Souvenir of New Orleans, Photogravures. Brooklyn, NY: The Albertype Company.

Stanforth-Louis Reens, Deirdre. *Romantic New Orleans*. New York City, NY: Viking Press, 1977.

Tallant, Robert. *The Romantic New Orleanians*. New York City, NY: E.P. Dutton, Inc., 1950.

Twine, Walter. *Left for Dead in New Orleans, The D.R. Twine Story*. Chicago, IL: Snockowitz Brothers, 1922.

Wilson Jr., Samuel. *The Beauregard-Keyes House*. New Orleans, LA: Keyes Foundation, 1993.

Wilson Jr., Samuel and Leonard Huber. *The Cabildo on Jackson Square*. Gretna, LA: Pelican Publishing Company, 1988.

Wilson Jr., Samuel and Bernard Lemann. *New Orleans Architecture, The Lower Garden District*. Gretna, LA: Pelican Publishing Company, 1991.